Images of 'Victorian' Hull

F. S. Smith's Drawings
of the Old Town

Text by
Carolyn Aldridge
*Museum Assistant, Hull City Museums
& Art Galleries*

Hull City Museums & Art Galleries
and the Hutton Press

1989

Published by Hull City Museums and Art Galleries

and the Hutton Press Ltd.
130 Canada Drive, Cherry Burton, Beverley
North Humberside HU17 7SB

Printed and bound by
Clifford Ward & Co. (Bridlington) Ltd.
55 West Street, Bridlington, East Yorkshire
YO15 3DZ

ISBN 0 907033 91 1

CONTENTS

FOREWORD

The drawings of F.S. Smith can be found in many households and premises throughout Hull, and they are a testimony to the enormous output of this prolific artist. Together the drawings form a record of the Hull of the late 19th and early 20th centuries which is probably unparalleled in any other city.

Hull City Museums and Art Galleries have some 700 Smith drawings in their collections, and these have been in constant demand by researchers for many years. In 1987 we decided that in order to make access easier to Smith's work we should like to produce a book of some of his drawings. Eventually, we chose to concentrate on the Old Town, where Smith's views record the patchwork mix of medieval, early modern, Georgian and Victorian which was so characteristic of the industrial city. This publication has been produced jointly by Hull City Museums and Art Galleries and the Hutton Press Limited.

In all, 122 views were selected, to give as wide a coverage as possible of the Old Town. So, we have famous views such as those of the "King Billy" Statue and Holy Trinity Church, with lesser known scenes such as those of a bustling Mytongate, or the yard of the *Cross Keys* hotel. It is these 122 views which comprise the exhibition at the Ferens Art Gallery, 11 November 1989 to 21 January 1990.

Hand-in-hand with our plan to make the Smith drawings more widely available we have begun a programme of conservation. Paper items are unstable at the best of times, and work to clean and stabilise such drawings can be very expensive. We are delighted, therefore, to acknowledge the most generous financial assistance of our sponsors, who have joined with us to preserve and exhibit these Smith drawings. It is our intention to strengthen our links with the local business community, and we are very pleased with the response we have had from local companies to this project.

Our thanks are also due to our Museums and Art Galleries staff for working so hard on this long-term and complex project. In particular we thank Carolyn Aldridge, Museum Assistant, who has been responsible for all research and much of the organisation, and David Fleming, Principal Keeper of Museums, for guiding the project through.

We hope in future, funds permitting, to publish and exhibit more Smith drawings, so that we can continue celebrating the rich past of this unique city.

Councillor Trevor P. Larsen, JP,
Chairman, Hull City Council
Cultural Services Committee.

John Bradshaw, MA,
Curator, Hull City Museums and
Art Galleries.

5

Companies sponsoring the conservation of the drawings

We are very grateful to the companies, listed below, for their generous support of the conservation of F.S. Smith's drawings of the Old Town.

Ove Arup and Partners Scotland
Barclays Bank plc
Blackmore Son & Co. — Chartered Architects
British Cocoa Mills (Hull) Ltd.
Burstalls — Solicitors and Commissioners for Oaths
Consolidated Fruit Co. Ltd.
English Estates
J. H. Fenner & Co. Ltd.
Gelder and Kitchen — Chartered Architects and Surveyors
Hodgson Impey — Chartered Accountants
Thos E. Kettlewell & Son Ltd. — The Shipbrokers
Kingston Communications (Hull) plc
Marsden Builders Ltd.
Hugh Martin Partnership
National Westminster Bank plc
Peat Marwick McLintock — Chartered Accountants
Radius Systems Ltd.
J.R. Rix & Sons Ltd. — Shipowners, Shipbrokers, Petroleum Distributors
Rollit Farrell & Bladon — Solicitors
Royal Mail Letters
Gordon Scott & Sons (Newland) Ltd.
Stamp Jackson & Proctor — Solicitors
The Corporation of the Hull Trinity House
Wells Cundall Commercial
William Younger Inns Ltd.

INTRODUCTION

Topographical painting and drawing, the depiction of real townscapes and landscapes, has a long history, dating back at least to the Roman period. Paintings of recognisable locations, for example the Harbour at Stabiae, were found in the ruins of Pompeii, Stabiae and Herculaneum, the towns destroyed by the eruption of Vesuvius in AD 79. Topographical scenes appear in medieval illuminated manuscripts and in the background of early 15th century oil paintings; by the 17th century paintings, prints and drawings of particular townscapes and landscapes were being produced throughout Western Europe. The 'Grand Tour', a promenade through Europe made by wealthy young men in the 18th century, encouraged topographical artists as there was a large demand from the travellers for pictorial souvenirs, and views of specific locations continued to be very popular in the first half of the 19th century. Such views can be invaluable evidence of how scenes and settlements once appeared, before changes in agricultural practice, transport and communications, industry and population growth all combined to alter the faces of town and countryside.

In the 1830s, photography was invented, and during the second half of the 19th century photographic techniques and processes steadily improved. Photography developed as a hobby for the middle-classes, and also as a commercial activity, and itinerant photographers travelled to smaller towns and villages, taking photographs to order. Photographs were also used increasingly to document the landscape and the townscape, largely taking the place of topographical paintings and drawings. Painting identifiable locations did not cease, but the purpose of such images changed, and by the end of the 19th century the 'street photographer' was taking over from the 'street artist' as the supplier of factual representations.

F.S. Smith worked during the last decades of the 19th century and the first decades of the 20th century before photography finally superceded the role of the topographical artist. His sketches provide detailed illustrations of the streets of Hull and the surrounding countryside, and perhaps may be described as the pictorial equivalents of 'snap-shots'. He was a prolific artist, often producing several versions of a scene. Smith's sketches of 'Victorian' Hull form an important archive and an incomparable local history resource. During Smith's own time Hull's appearance altered, and between 1889 and 1989 the townscape has changed enormously. The value of Smith's work was recognised in his lifetime; his drawings were collected by the amateur historian, C.E. Fewster, who also employed Smith to record the disappearing streets and buildings in the town. According to an obituary in the *Hull Daily Mail* (28 September 1925) Smith's work was also admired by the artist and critic John Ruskin. Ruskin appreciated the importance of topographical painting and drawing, "Pure history and pure topography are most precious things, in many cases more useful to the human race than high imaginative work ..." and he defended topographical artists, for although topographical paintings, drawings and prints were popular, to be a topographical artist was less acceptable in the 19th century than being an artist who produced works of imagination.[1]

The 122 drawings published here are a selection of those Smith made of the Old Town of Hull over the period c.1880-1925. All are from the collections of Hull City Museums and Art Galleries, which hold over 700 drawings and watercolours by Smith. We decided to publish our Smith drawings to improve public access to this unique record of the city. Physical access to the originals has to be restricted because of their delicacy: such works on paper have little resistance to light, dust, atmospheric pollution, moisture and handling. Indeed, our publication project had to begin with a programme of conservation, the drawings costing up to £150 each to conserve. This enabled us to clean the drawings, remove glues and various other substances which had been attached to them in the past, remove foxing, and repair tears and holes. Generous support from our sponsors, acknowledged elsewhere in this volume, has met part of these costs, and has made possible the publication of more drawings in the future, those showing the growth of Hull outside the confines of the Old Town. Moreover, the long-term future of the conserved originals is now guaranteed, ensuring that future generations can still benefit from that magical 'face to face' contact when the drawings are exhibited by our successors.

Carolyn Aldridge,
Museum Assistant (Social History)
David Fleming,
Principal Keeper of Museums

Notes:

[1] Ruskin, John *Modern Painters*, quoted in Links, J.G. *Townscape Painting and Drawing*, 1972, B.T. Batsford, London. p.3.

Hull's Old Town: Location of Drawings

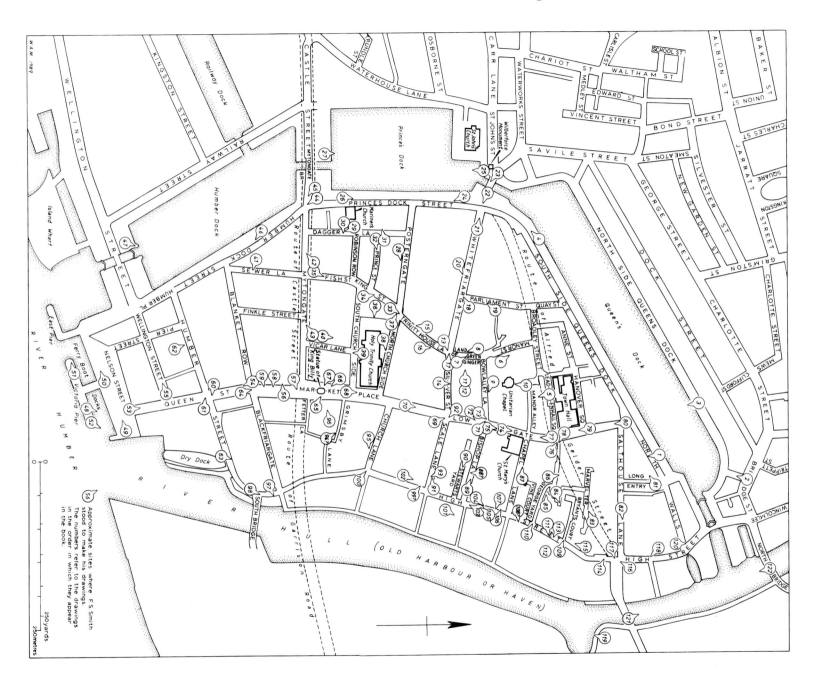

Approximate sites where F S Smith stood to make his drawings. The numbers refer to the drawings in the order in which they appear in the book.

250 yards
250 metres

9

SMITH'S HULL

The 19th century was a time of enormous change and development. By the end of the century Britain had changed from the predominantly agricultural state of about 100 years earlier into a major industrial nation, the "workshop of the world". Important political reforms had taken place: the right to vote had been extended (although it still did not include all adult men, and women were excluded completely), local government had been reformed and trade unions legalised. Social changes had occurred: free compulsory schooling had been introduced and the position of women was slowly beginning to improve. The 19th century was also a golden age of innovation and invention; many features which are accepted now as part of everyday life were introduced during the period, for example railways and anaesthetics. The developments taking place nationally affected, and were reflected by, local developments in Hull and elsewhere. These social, political and economic changes, and the introduction of such innovations as gas street lighting in turn affected the physical appearance of the town; changes which were recorded in the drawings produced by F.S. Smith between about 1880 and 1925.

THE CHANGING FACE OF HULL

F.S. Smith was brought to Hull by his parents as a small child in the 1860s. At that time Hull was expanding rapidly (by 1891 it was the tenth town in England in terms of population), spreading out to the north, west and east of the original town. The municipal borough boundaries had been established in the 1830s with the intention of allowing for urban development, but the growth of the town between 1861 and 1881 was such that the boundaries had to be extended in 1882. They were changed again in 1897, the year Hull became a city.

The medieval settlement had developed on a natural site for a port, where the River Hull flowed into the Humber estuary, providing a safe anchorage. Protected on the south and east by water and to the north, west and south by walls, the town had flourished but there was no major expansion outside the original area until the destruction of the town walls and the construction of the first docks (Queen's Dock, Humber Dock and Prince's Dock) in the late 18th and early 19th centuries. Instead, most of the open land within the town walls had been built on. This in-filling of space behind and between other buildings resulted in a closely-built, crowded town containing many small courts,

entered through narrow passages from the streets or from other courtyards.

By 1800 no further house building was possible within the Old Town and therefore Hull had begun to spread outside the new docks. Merchants and other wealthy citizens began to move out of the Old Town to the new suburbs and the surrounding countryside. Housing for working people also began to be built beyond the ring of the docks, and despite the fact that Hull continued to grow, the population of the Old Town itself started to decline, from 17,000 in 1861 to 11,000 in 1881. The 'new town' of Hull had not been planned coherently and problems which had been found in the Old Town, such as court housing, soon developed in the new Georgian and Victorian areas of Hull. Although some streets in the new areas were carefully planned, the main routes through Hull in the later 19th century were often confused by smaller streets. It was not until 1899 that the City Council was granted powers to construct the first thoroughfares in Hull.

The town of Hull expanded in the 19th century in response to the demands of its increasing population. In 1881 the Medical Officer calculated that the birth rate in the municipal borough was 36 per 1,000 and the death rate was 23 per 1,000. The population increased partly as a result of a number of births; there were about 25,000 more births than deaths in the 1870s. The population also grew because of the number of people migrating into the town — about 17,000 over the same period.[1] The developing trade and industry in Hull encouraged migration as it offered the prospect of employment both to labourers and craftsmen from the UK and Ireland, and to immigrants from the Continent; in 1881 there were 128 Russian-born and 227 Polish-born people in Hull.

THE TRADING PORT

Although Edward I had acquired Hull as a supply port for his Scottish campaigns, the town's prosperity was built upon trade, particularly with Northern Europe — Scandinavia, Russia, the German States and the Low Countries. Before the mid 19th century when the railways developed, most goods were transported by water and Hull, linked by navigable waterways to the industrial areas of the Midlands and Northern England, provided a valuable inlet for raw materials and outlet for manufactured goods. The construction of the town docks, necessitated by the amount of shipping using the Haven (the

River Hull from the mouth to North Bridge), the opening of rail links to the West Riding, and the development of more docks in the second half of the 19th century aided Hull's trade, and from the mid 19th century Hull was ranked as third port in the country after London and Liverpool.

In the 19th century (and into the 20th century) Hull continued to trade mainly with the countries of Northern Europe and traditional commodities such as timber, oil seed and grain, continued to be carried. Because of this dependence on Northern Europe, trade in Hull was seasonal, as the Baltic froze in winter. There was some trade conducted outside Northern Europe in the first half of the century, but the overseas trade did not begin to expand until the 1870s and 1880s when trade in oil seed and grain developed with the Argentine, North America, the East Indies, India and the Southern European ports of Marseilles and Trieste. One difficulty the port had throughout the period was that although ships sailed into Hull with full holds, they often sailed from the port without cargoes, 'in ballast', which was less profitable. This was because Hull's exports required less space than the town's bulk imports such as grain. In the latter part of the century, however, the severity of the problem was reduced by the growth of the coal export trade.

INDUSTRIES IN THE TOWN

Hull's primary importance was as a port, not as an industrial town, but several manufacturing businesses developed in the town, and by the 19th century industry in Hull was notable for its diversity. These various industries can be grouped roughly into three types: industry connected to the port and to the sea, such as shipbuilding and fishing; industries related to the trade of the port, for example milling and seed-crushing; and other industries.

Shipbuilding was one of the oldest industries in the town, and in the 19th century a substantial number of people were employed — there were 1,205 shipbuilders and shipwrights in Hull in 1871. The fishing industry developed in Hull in the 1840s when fishermen from Brixham and Ramsgate settled in the town. The industry expanded quickly; in 1841 there were four men and boys employed, and in 1881 there were 1,578.[2] Ancillary trades such as ice-making and fish-curing developed in the port and dock work was also dependent on Hull's trade and maritime industries; in 1891 27.7% of working men in Hull were employed in transport work, and of this figure 7% were dock workers.[3]

Hull, situated near the oil seed growing areas of Eastern England and Northern Europe, had grown into a centre of the seed-crushing industry. Improved extracting methods, and increasing demands for oil and oil-based products, encouraged the industry in the 19th century, and by 1872 there were 40 oil mills in Hull. The production of animal feeds developed as the crushed seeds provided valuable nourishment for cattle. Paint manufacture, also dependent on the seed-crushing industry, may have begun in Hull as early as 1749 but the industry did not develop fully until the 19th century; in 1889 there were 24 paint manufacturers and dealers listed in the town directory. Smith's patron, C.E. Fewster, was a paint manufacturer.

Like seed-crushing, the grain-milling and cotton manufacturing industries in Hull were also linked to the trade of the port. The Hull Flax and Cotton Mill opened in 1836 and the Kingston Cotton Mill in 1845. The mills provided employment for a large number of people; 735 men and 1,179 women were employed in 1861; but both eventually failed — the Hull Flax and Cotton Mill in 1866 and the Kingston Cotton Mill in 1894, largely because of their local managers' lack of knowledge of the cotton markets. Grain-milling, however, was successful in Hull. In the 1880s British milling was facing competition from abroad but Joseph Rank adopted the new roller milling machinery and installed it, instead of traditional grindstones, in his mills, the Alexandra Mill (1885) and the Clarence Mill (1891), producing a more saleable flour.

Industries related to the port and its trade were important in 19th century Hull but other industries also played a significant part in the town's economy. Cement production, leather-working, starch manufacture, and sweet-making contributed to the town's prosperity. The diversity in the town's industries was also found in the range of smaller businesses, which covered the usual shops and services of the period such as bakers, butchers and hairdressers, and also included umbrella-makers and bird-stuffers (there were three listed in the town directory in 1889).

LIFE IN THE OLD TOWN

In the 19th century many of Hull's poorer citizens lived in the inner areas of the city, including the Old Town. Although the main streets of the Old Town were lined with business premises, the areas between the streets were crowded with dwellings, "... the only unalterable law of construction ... having apparently been that a passage — wide enough for a human being — must be left somewhere to afford communication with the outer world".[4]

Many of the houses had been cheaply constructed by speculative builders; they turned into slums like the houses in Dixon's Entry which in 1884 were, "... in great part rotten and filthy, the woodwork decayed, the windows often partly gone and replaced with old mats and hay".[5] Such courts were frequently overcrowded — in the 1840s there were 46 people living in three houses in George Yard — and in the damp and poorly ventilated dwellings tuberculosis was rife.

Providing the low-lying town with clean water had been a problem from the Middle Ages. Following the cholera epidemic in 1849 the campaign for sanitary reform strengthened, and from 1865 a clean and sufficient water supply was found, but many homes continued to depend on a shared stand pipe. Improvements were also made to the sewage system but sanitation in a lot of houses remained almost non-existent. A cesspool in the courtyard would serve several dwellings and when houses had privies these might leak; in Finkle Street liquid from a privy seeped under the bed of a woman next door. The atmosphere was polluted by the smells from the courts and the 'muck-garths', (where 'nightsoil' was kept before being sold as manure), by industrial fumes and by soot and smoke from ships in the docks and from factories. Disease flourished in this environment and 19th century Hull was hit by typhus, typhoid, smallpox and scarletina.

Many of Hull's citizens also endured poor working conditions. The hours of work in many businesses were very long, which increased the risk of injury, especially among child workers, and the unpleasant surroundings often affected the health of employees. The grain and cotton mills were very dusty, some oil seeds caused eye and skin irritation, and paint manufacture caused lead poisoning. Fishing was also very dangerous — 180 men were lost at sea in March 1883 — and fishing apprentices were frequently badly treated, the cruelty sometimes leading to murder, as in a case in 1881.

Hull in the 19th century was a city of contrasts — between wealth and poverty, fine buildings and slums, advanced technology and traditional practices, and indifference and reforming zeal. During the period the town underwent enormous changes, expanding physically and developing into an industrialised city and a major port. The 19th century city has now largely disappeared, but it is still possible to open windows on Victorian Hull by studying the drawings of F.S. Smith.

Notes:

[1] The figures for the increase in population by births and immigration are taken from ed. Allison, K.J. *The Victoria History of the Counties of England, A History of the County of York East Riding*, 1969, Oxford University Press, Volume I, p.245, Table 5, and include some population figures from outside the municipal borough boundaries.

[2] The Census did not record those at sea on the night of the survey.

[3] Transport was a Census category, covering employment on railway, road, sea, river and canal transport, docks, harbours and warehousing. The percentages are taken from Bellamy, Joyce M. *Occupations in Kingston upon Hull 1841-1948* in the *Yorkshire Bulletin of Economic and Social Research*, January 1952, Universities of Leeds, Sheffield and Hull, Volume 4, Number 1, p.41.

[4] Lambert, Revd J.M. quoted in *Homes of the People*, 2 February 1884, *Eastern Morning News*, reprinted as *Malet Lambert Local History Reprints*, 1984, Hull, Local Volume Number 67, p.5.

[5] *Ibid*, p.6.

FREDERICK SCHULTZ SMITH
Biographical Notes

Frederick Schultz Smith was born in Worthing, Sussex, in August 1860, shortly before his parents, Edward Henry Smith, a housepainter, and his wife Mavis, moved north to Hull.[1] It is possible that there may have been a link between F. S. Smith's father and the artist's patron, C. E. Fewster, who was a paint manufacturer; it is conceivable that Edward Smith worked in Fewster's factory.[2] Fewster, however, collected local topographical views, which provides sufficient reason for his patronage of F. S. Smith without any additional links between the two men. F. S. Smith was not an only child. There was at least one other child in the Smith family, a daughter, Annie, and there appears to have been some closeness between the brother and sister as Annie, who never married, is presumably the unmarried sister recorded as living with the artist at the time of his death.

F. S. Smith's residence in 1890 is noted as being 2 Low Street, (*Hull Times*, 16 August 1890) which may be a misprint; in 1895 his address was Rose Street (*White's Directory*, 1895) where he lived until 1913 or after. His address at the time of his death was Eastbourne Avenue, Arundel Street, off Holderness Road. Smith died on 26 September 1925, at the age of 65, in Hull Royal Infirmary, after suffering a short illness, and was buried in Hull General Cemetery.

There are contradictory accounts of Smith's artistic training. One version (*Hull Daily Mail*, 1 October 1925) states that the artist's talent was encouraged by the vicar of St. Mary's, Sculcoates, the Revd. W. J. Pearson, who paid the first term's fees for Smith so that he might study at the Hull School of Art (founded in 1861). A conflicting report in the *Hull Times* (3 October 1925), however, notes that the artist "... had no School of Art training, but he had a natural gift". Whatever the facts of the matter, Smith appears to have shown early talent — a picture reproduced in the *Hull Times* (8 June 1935) was supposedly drawn when he was 13 years old — and by the time he was 30 his work was receiving encouraging reviews; a favourable criticism in the *Hull Times* (16 August 1890) mentioned his "... careful study and painstaking execution" and his works are referred to as being "... exceedingly pretty ... deserving of notice ...[and showing] considerable promise". During his career his work was praised by John Ruskin, who may have bought one of his drawings. Other admirers included Sir Albert Rollit, the Mayor of Hull in 1883 and 1884 and Thomas Sheppard, the Director of Hull Museums, who described his work as being "... of exceptional merit ..." (*Hull Museum Publication* No.165, 1929)

and commented on the amount of detail in the sketches.

Smith was commissioned by C. E. Fewster to make topographical drawings of Hull, especially of the areas of the town which were being demolished and re-developed. The manufacturer had a large collection of drawings, nearly 300 in number (which now form the basis of Hull City Museums' collection), but Smith also produced drawings for other people and organisations. His sketches were used as book illustrations and published in the local newspapers — the *Eastern Morning News* reproduced several of his sketches, and series of drawings were also made for other local papers — but much of his work was sold to the individuals or to the companies whose premises he had drawn.

> ...he skilfully drew here a pretty little piece of Old Hull, filling in the background with a typical building, and there he produced artistically a shop front, a suite of more or less imposing offices and a cake mill, which he disposed of for a price to the owner, the merchant or the shopkeeper.

> (*Hull Times*, 3 October 1925)

The same article also mentioned that Smith was well known in the town, "... especially to those taking an interest in artistic advertising", and several of his sketches are known to have been used as advertisements for specific shops and businesses.

In the newspaper article referred to above Smith is described as "... a street sketch artist", and in the town directories he is listed as an artist or as a scenic artist but in most of his obituaries he is referred to as a "black and white artist". The majority of the drawings were done in pen and ink but Smith also produced pencil sketches and watercolours; the review in the *Hull Times* (16 August 1890) referred to his "... watercolour drawings". An obituary in the same paper (3 October 1925) described his technique:

> Mr. Fred Smith was a familiar figure in our bustling city, with his attaché case and sketch book at street corners, as with his pen he skilfully drew ... His earlier work was considered by art people to be his best. In those days his work consisted entirely of pen and ink sketches, with wonderful truth to detail, but more recently ... the brush was introduced for the purpose of light and shade effects, and the sketches probably lost something of their charm.

Smith continued to produce drawings until very shortly before his death; the *Eastern Morning News* (29 September 1925) noted that he was sketching in Manor Street a few weeks prior to his death. The *Hull Times* (3 October 1925) referred to "... a greater demand for his work ..." which, combined with the artist's probably failing eyesight, led to the production of the ink and wash drawings. These were considered by some people "... to be not quite so satisfactory ..." and Smith's drawings may have declined in popularity as a result. There is some information which hints at the artist's fading reputation and lack of prosperity in later years. An article in the *Hull Daily Mail* (1 October 1925) mentions Smith, "... at one time well known locally as a black and white artist" and another newspaper report (*Hull Times* 3 October 1925) refers to "... the older generation ..." owning his drawings and displaying them in their business premises. A letter to the editor of the *Hull Daily Mail* (1 October 1925) alludes to "... hard times ..." and between 1913 and 1919 Smith moved house from the pleasant suburb of St John's Wood to the less attractive area of early 20th century Holderness Road. After 1913 Smith does not appear to have been listed in the town's directories. The criteria for inclusion in the directories are not known but appear to have been dependent in part on social status, or may have involved the payment of a fee. A decline in Smith's popularity and prosperity might also have resulted in a decline in social status and/or a lack of funds with which to pay a directory fee. Whether or not Smith did suffer some loss of estimation, his reputation did not disappear, as the newspaper reports of his death illustrate; the *Hull Times* (3 October 1925), for example, stated that Smith "... had a reputation which many aspirants would have been proud to have possessed ..."

There are some details available about Smith's life and working methods, but there is little information about his physical appearance and character. He was left-handed, which was unusual in an era when children when encouraged to be right-handed, and he worked in a quiet and unostentatious manner, remaining indifferent to passers-by who stopped to watch him. He worked rapidly and the large number of surviving sketches, combined with references to the fact that he was a familiar figure in the streets of the town, indicate that he was hard-working. A letter of testimony (*Hull Daily Mail*, 1 October 1925) described him as "... one of the cheeriest Christians one could meet ..." and "... a number of neighbours and friends ..." (*Hull Times*, 3 October 1925) attended his funeral, which, with the account of the numerous wreaths sent, suggests that he was well-liked. Many other details about Smith's life, work and personality, however, are lacking; the man who in his drawings provides so much information about the town in which he lived has left little information about himself and remains a slightly mysterious figure.

Notes:

[1] *Hull Daily Mail* (1 October 1925). I have been unable to verify this reference.

[2] This has kindly been suggested to me by Arthur Credland, Keeper of Maritime History, Hull City Museums and Art Galleries.

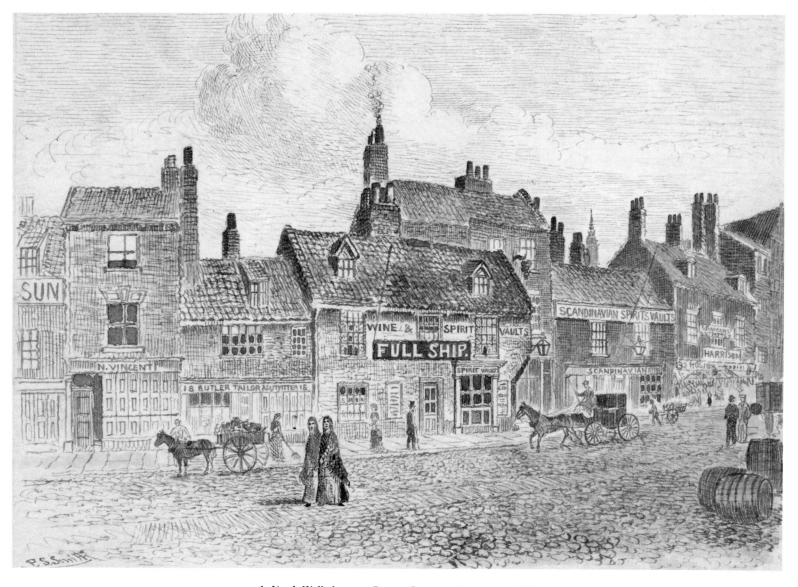

1. North Walls between Perrott Street and Lowgate, c.1885
(Acc. No. 178.1929)
Sponsored by Kingston Communications (Hull) plc

Alcohol abuse was a major problem in 19th century Hull. Drink was readily available — there were 117 fully licensed premises in the Old Town alone in 1893 — and the pub offered a warm, sociable refuge from the damp, overcrowded and cold homes in which many working people lived. Drink probably increased the poverty of many of Hull's citizens; many working men, for example dock labourers, were paid in the public houses where they were encouraged to spend their wages on drink; and alcohol abuse also damaged the health of many people. Smith's sketch illustrates four of the five pubs and inns in North Walls — the *Rising Sun*, the *Full Ship*, the *Scott's Head* (partially hidden but marked by the bunch of grapes), and the *Scandinavian*.

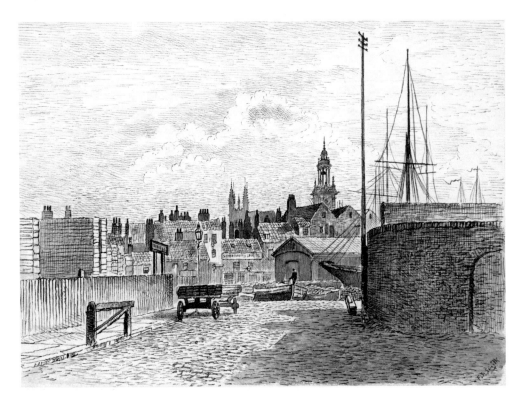

**2. Queen's Dock Side and North
Walls from Bridge Street,
c.1885**
(Acc. No. 394.1929)
A view from the north side of
Queen's Dock, showing the
east end of the dock, near to
the River Hull. The towers of
St. Mary's and the old Town
Hall are visible on the skyline.

**3. Queen's Dock looking south
to Lowgate, c.1884**
(Acc. No. 386.1929)
This drawing was made from
the north side of the dock,
looking down Lowgate. The
brig *Alert* in the centre of the
sketch is probably a Peterhead
vessel, built in 1853 and still in
use in the 1880s.

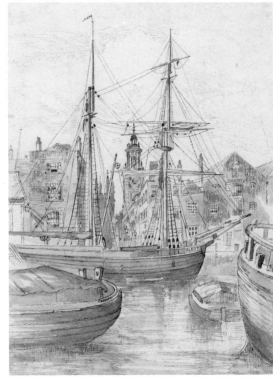

18

4. Wilberforce Monument and St. John's Church from Queen's Dock Side, c.1885
(Acc. No. 87.1929)
Sponsored by Hodgson Impey – Chartered Accountants

Queen's Dock, the first dock constructed in the town, was opened in 1778 and named Queen's Dock to commemorate Queen Victoria's visit to Hull in 1854. It became redundant in the 1930s, was filled in and re-opened as Queen's Gardens in 1935. This view along the south side of Queen's Dock shows Wilberforce Monument in its original position, west of the lock-pit, by Monument Bridge. St. John's Church, behind the monument, was built by the evangelical Christian, Thomas Dykes, and consecrated in 1791. The site is now occupied by the Ferens Art Gallery. The sheds on the right of the picture were used to shelter the cargoes of the ships in the dock. Goods could be transported to and from the dock by railway and railway trucks are depicted at the left side of the sketch.

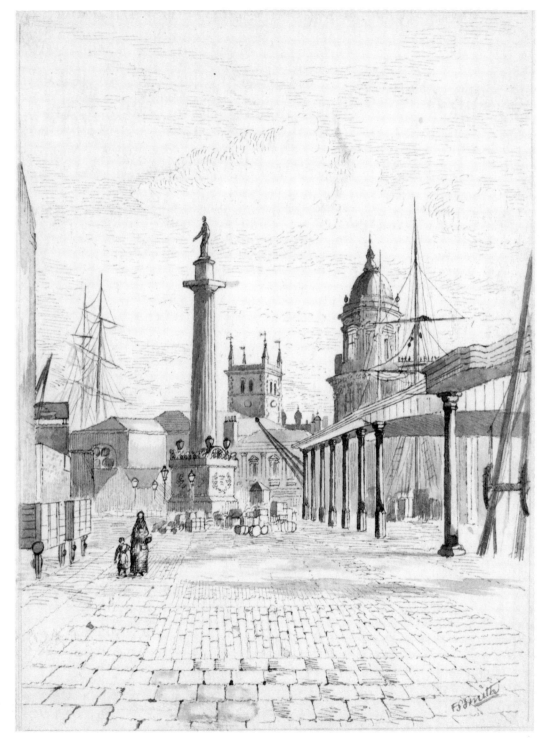

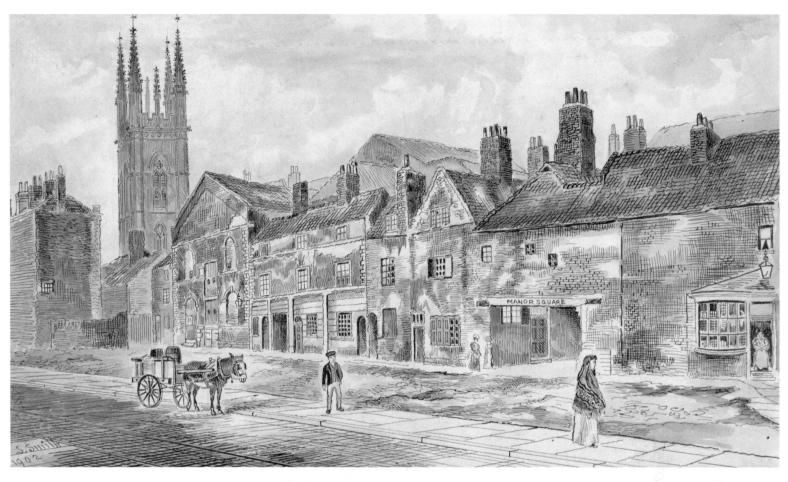

5. Manor Alley during the construction of Alfred Gelder Street, 1902
(Acc. No. 415.1981.20)

At the beginning of the 20th century major street improvements were carried out to create thoroughfares across the town, during the course of which many buildings were demolished. Alfred Gelder Street was cut across the Old Town to provide a west-east route for traffic in Hull. Smith's drawing shows Manor Alley at the time of the construction of the new street. The buildings on the north side of the alley and on the south side of Leadenhall Square have been demolished. All that remains in Smith's drawing is a strip of rough ground between Manor Alley and the new street. Leadenhall Square was notorious in the 19th century as a 'red light' district and it was suggested in mid-century that the square should be knocked down as it constituted a legal nuisance. The clergy and organisations such as The Society for the Suppresssion of Vice battled against immorality in Hull but the character of the area did not change until the construction of Alfred Gelder Street.

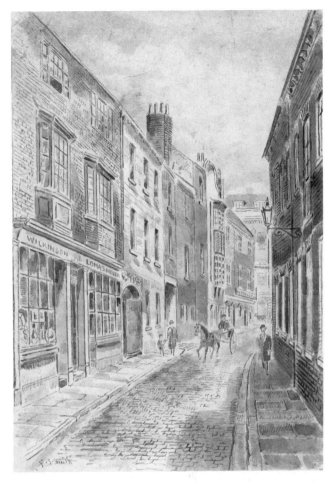

6. Manor Street from the Land of Green Ginger, c.1925
(Acc. No. 415.1981.21)
This sketch was published in the *Eastern Morning News* (29 September 1925) with the caption "... the last drawing of the late Mr. Fred Smith ..."

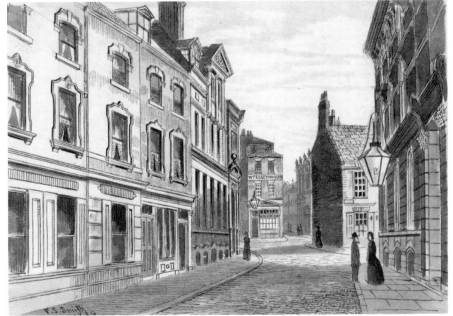

7. The Land of Green Ginger from Silver Street, 1889
(Acc. No. 76.1929)
The Land of Green Ginger has changed very little since F.S. Smith sketched the street 100 years ago and several firms continue to work from the same premises as they did in 1889.

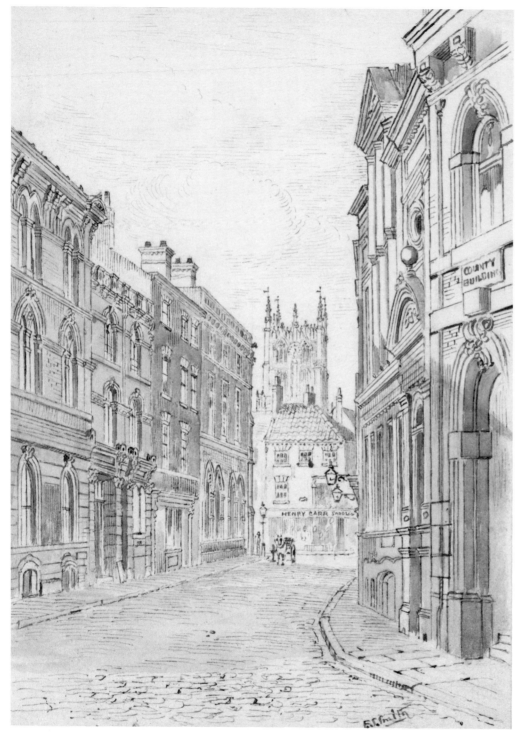

8. The Land of Green Ginger looking south, c.1883
(Acc. No. 71.1929)
Sponsored by Wells Cundall Commercial

The origins of the name "Land of Green Ginger" are unknown but various theories have been put forward in explanation, ranging from a place where ginger was grown or sold to the corruption of the name of a young Dutchman "Lindegroen Jonger". This drawing was made from a viewpoint at the top of Winter's Alley, looking down the road to Silver Street. The building on the corner of the Land of Green Ginger and Silver Street was a branch of the London and Yorkshire Bank Limited. The town's first banker was Joseph Pease, who opened Pease & Son's bank in 1754; by 1889 there were nine banks listed in the town's directory. The Hull office of Lloyd's Register of British and Foreign Shipping was also situated in the building.

9. Bowlalley Lane looking east to Lowgate, c.1885
(Acc. No. 641.1982.17)

Bowlalley Lane, formerly Bishopgate and Denton Lane, was named after a bowling alley which stood in the area. Cogan House, the gabled building on the left of the drawing, was used as offices, and one of the entrances under the central arch gave access to the alleys behind the building where other offices, such as Lincoln's Inn Buildings, were situated. Court housing also stood in the area behind Bowlalley Lane and the Revd. J.M. Lambert, a prominent social reformer in the 1880s, described the modern business premises as "... lines of veneer ..." on the street frontages, hiding the squalor behind.[1] The two women walking down the street are probably fairly well-off as they appear to be wearing hats and the fashionable ruched, draped and pleated dresses of the early 1880s. The men in the foreground may be business men; the man on the right appears to be wearing a top hat and formal office clothes.

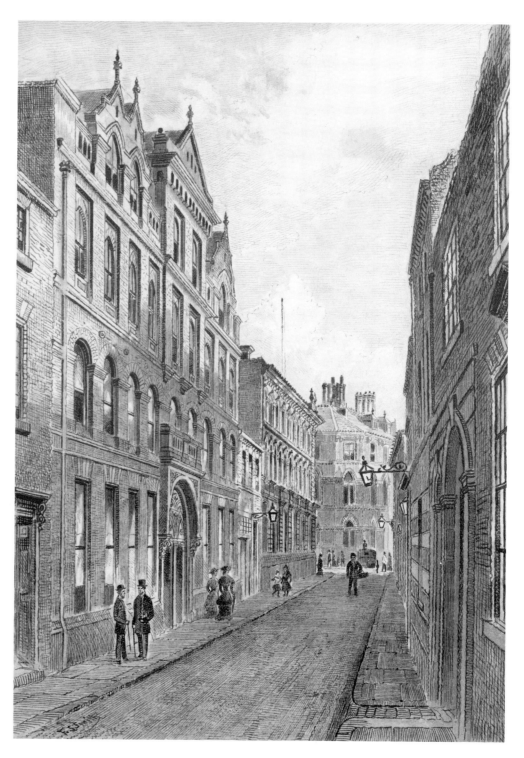

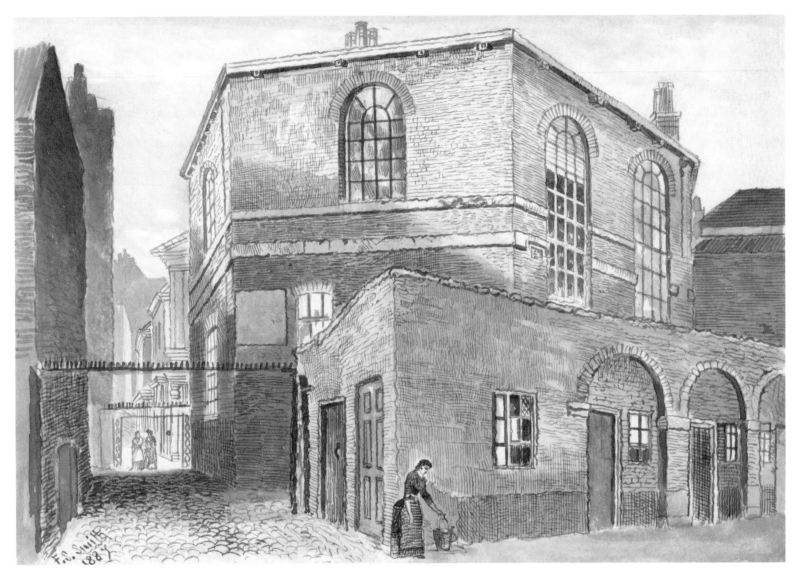

10. Unitarian Chapel, off Bowlalley Lane, 1887
(Acc. No. 248.1929)

Bowlalley Lane Chapel was the oldest dissenting place of worship in Hull. The chapel was re-built, in octagonal form, in 1802-3 and became a centre for Unitarian worship in 1806. It was sold in 1881 and the building, which appears to have been renamed Lincoln's Inn Buildings, was used as offices. In 1910 the former chapel stood in the yard of the new Post Office on Lowgate. It was demolished in 1936.

The woman in the centre of the sketch is filling a bucket at a water tap. In the 19th century many people living in the Old Town relied on a communal water tap in the yard and collecting water for drinking, washing and cleaning was a tedious chore. The building with the arched doorways, near which the woman is standing, appears to front onto Manor Square and may be the "... building of four arches, said to have been the stables of ... [Suffolk] palace, but now used as detached kitchens for four houses in Manor Alley".[2] Manor Alley lay on the north side of Manor Square; Suffolk Palace was the manor house of the de la Pole family which formerly stood in the area. By 1929 the building had been demolished.

24

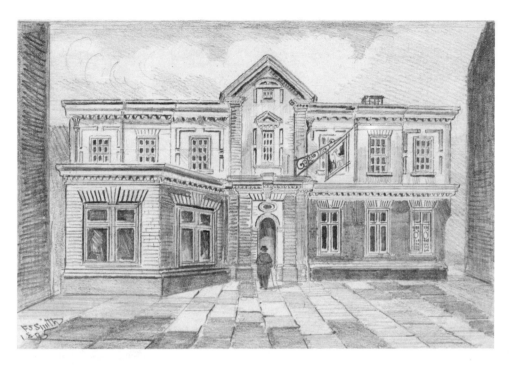

11. Ye Olde White Harte, 1895
(Acc. No. 19/51.4)
Sponsored by William Younger Inns Ltd
 The White Harte Inn dates from the 17th century. The building was supposedly used by Sir John Hotham, Governor of Hull at the beginning of the Civil War, as his residence.

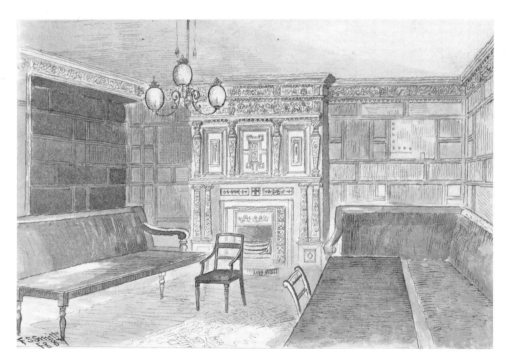

12. The Plotting Parlour, Ye Olde White Harte, 1887
(Acc. No. 322.1929)
Sponsored by William Younger Inns Ltd
The Plotting Parlour is traditionally the place where Hotham and his councillors decided to refuse Charles I entry into Hull in April 1642, an act which foreshadowed the Civil War. If the tradition is to be believed, this is one of the country's most historic locations.

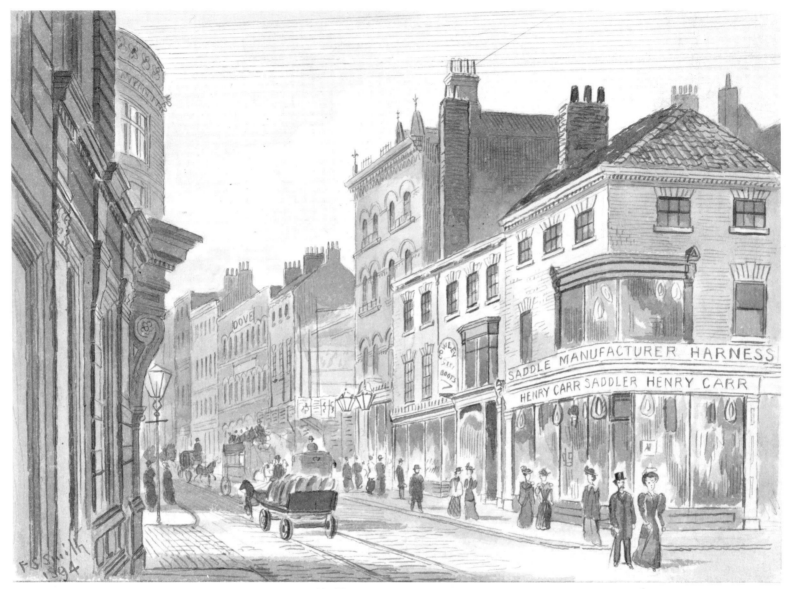

13. Silver Street, looking east, 1894
(Acc. No. 415.1981.30)
Sponsored by Barclays Bank plc

Silver Street, along with Whitefriargate and Scale Lane, formed one of the major west-east routes through the medieval town. The three streets originally formed one street, known as Aldgate, but the name changed between 1350-1500 to Scale Lane and Whitefriargate; the name Silver Street appears in the 17th century. The road may be named for the silversmiths of the town. Although various offices stood on Silver Street, shops were also situated there, including milliners, hosiers, tailors, boot-makers and saddlers. The pedestrians illustrated appear to be smartly dressed — the shops on such a busy road would cater for the wealthier citizens — and the woman in the foreground, crossing Trinity House Lane, is wearing the fashionably full puffed sleeves and tailored bodice of the period. Various vehicles are depicted in the drawing — a rully ladened with sacks, two carriages, and a horse-drawn omnibus. Omnibuses were introduced into England by George Shillibeer in 1829 and rapidly became a popular form of public transport.

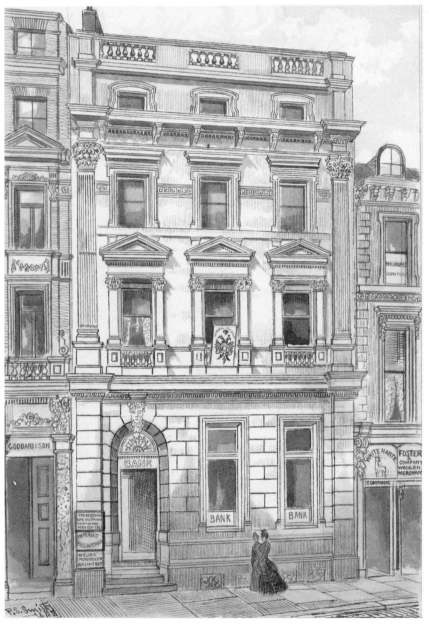

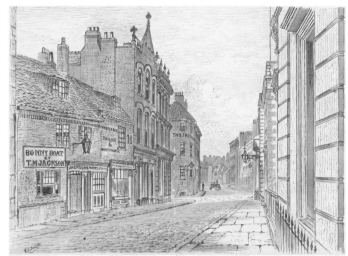

15. Trinity House Lane, c.1883
(Acc. No. 72.1929)
A view looking south along Trinity House Lane. The
Bonny Boat pub was named after an Eskimo canoe
brought back from Greenland to Trinity House in 1613.
The canoe is on display inside Trinity House.

14. The Exchange and Discount Bank, Silver Street, 1888
(Acc. No. 335.1929)
As well as the Bank, the building also housed the offices of the
Russian Consul, and the two-headed eagle, the emblem of Imperial
Russia, may be seen displayed on the building.

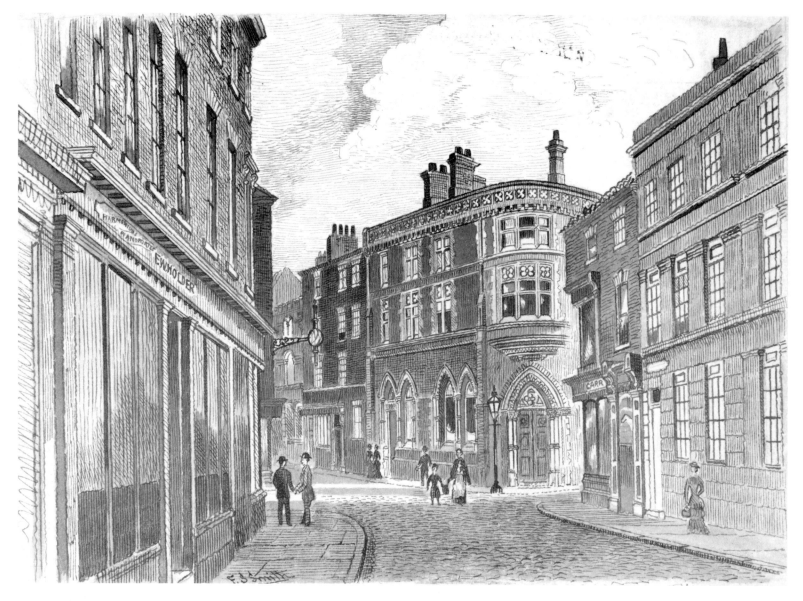

16. The Land of Green Ginger from Trinity House Lane
(Acc. No. 51.1929)
Sponsored by National Westminster Bank plc
The drawing illustrates the cross-roads of Whitefriargate, the Land of Green Ginger, Silver Street and Trinity House Lane as it appeared in the last decades of the 19th century. The buildings on the corner of Silver Street and Trinity House Lane, including the shop of Henry Carr, the saddler, have been replaced by banking premises. The red brick offices of the London and Yorkshire Banking Co. on the corner of Silver Street and the Land of Green Ginger, which were built in the 19th century 'Gothic' style, have also been replaced by more modern bank offices.

17. *Whitefriargate from Silver Street, 1887*
(Acc. No. 90.1929)
Sponsored by Barclays Bank plc
The elaborate building on the corner of Whitefriargate and the Land of Green Ginger was built in 1886 as the offices of the Colonial and United States Mortgage Co. Ltd. The premises are "... in the French Renaissance style, of the most ornate type. We may say that this is one of the most elaborate exteriors to be found in Hull, and being entirely faced with stone, is of very attractive elevation".[3] The *George* hotel stands next to the offices, which are now used by a building society and an insurance company, and beyond the hotel stood the unusually named *Royal Flowerpot* public house. Whitefriargate gained its name from the Carmelites or White Friars who had a friary on the street until 1539. The road was formerly part of Aldgate.

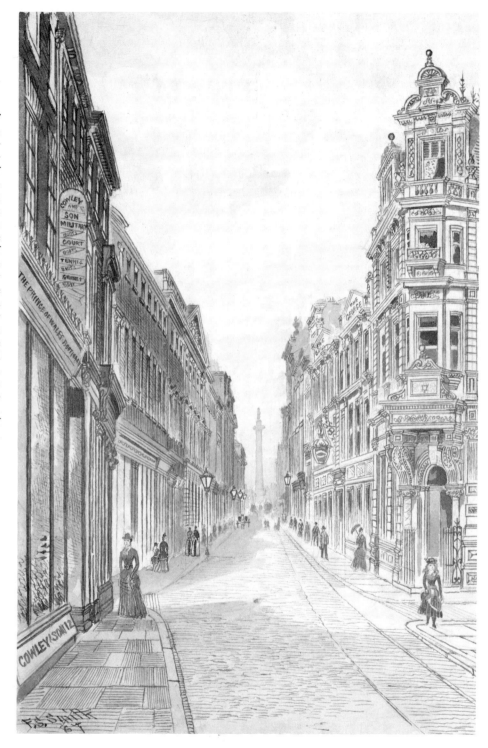

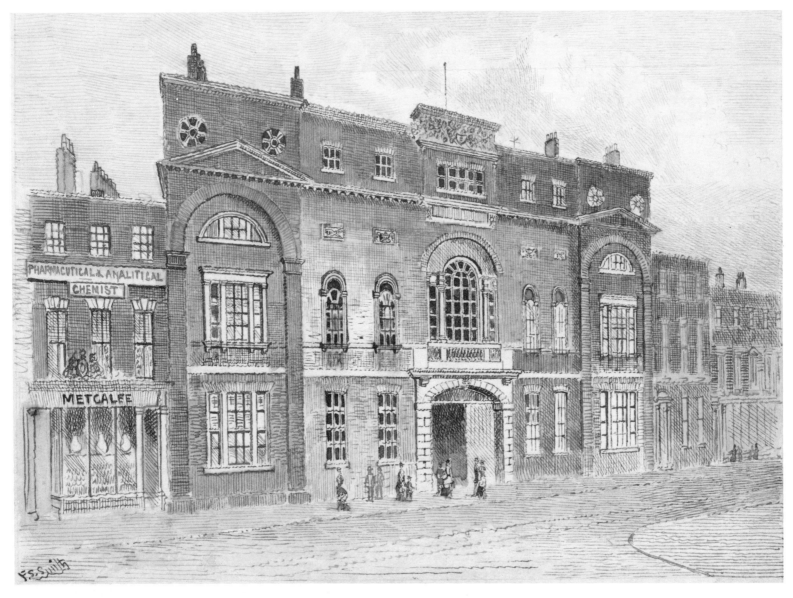

18. The Old Custom House, Whitefriargate, c.1883
(Acc. No. 130.1929)

A guild in honour of the Holy Trinity was founded in Hull in 1369 and in about 1456 the character of the organisation changed from a religious to a craft guild, which became known as the Guild or Fraternity of Masters and Pilots, Seamen of the Trinity House of Kingston upon Hull. Trinity House was a major landowner in the Old Town and from the early 18th century the Guild began to improve its properties, partly in order to be able to charge higher rents. The *Neptune Inn* was built as the centrepiece of the remodelled Whitefriargate properties and was opened in November 1797. The architect was George Pycock, and his design emphasised the first floor ballroom with its Venetian window. Although the inn was situated in a central position and was well furnished, it was not a commercial success and in 1815 it became the Custom House. HM Customs remained in the building until 1911 and the building has since been converted into shops.

19. Parliament Street, looking towards Whitefriargate, 1883
(Acc. No. 80.1929)
Sponsored by Stamp, Jackson & Procter – Solicitors

Parliament Street was described in the late 19th century as "... the abode of law and order ..." as many solicitors had their offices in the street and the Central Police Station was also situated there.[4] In Smith's sketch a line of policemen can be distinguished marching down the road. Prior to 1836, when a unified police force was established in the town, policing duties were carried out by a few constables and watchmen. The police force, which in 1890 consisted of 278 men, was housed, after 1852, in the old workhouse; the police station had cells for prisoners and barracks for about 60 policemen.

Parliament Street was named after the Act of Parliament which was obtained in 1795 to compulsorily purchase part of the site of the new street. The workhouse on Whitefriargate, which was closed in 1852, extended behind the houses on the west side of the street so the affluent and the destitute lived next to each other. The workhouse was regarded by residents of the street as a breeding ground for disease.

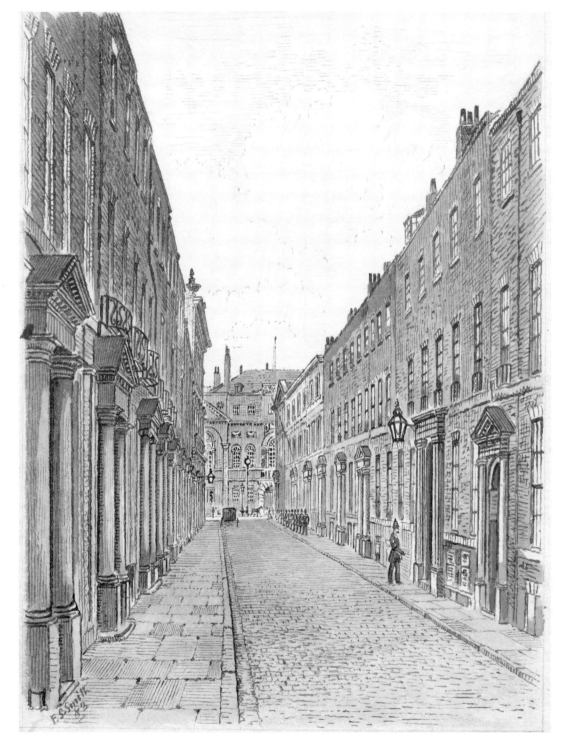

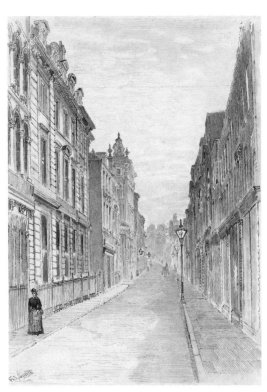

20. The Bank of England, Whitefriargate, looking towards Silver Street, c.1885
(Acc. No. 75.1929)
The Hull branch of the Bank of England was formerly situated in Salthouse Lane but moved to Whitefriargate, into a stone building constructed in 1859 on the site of the old Charity Hall.

21. Whitefriargate and Wilberforce Monument, c.1887
(Acc. No. 100.1929)
Sponsored by Ove Arup & Partners Scotland
Whitefriargate, like Silver Street, was a busy shopping street. The establishment next door to Henry Dixon, silk mercer and draper, was the shop of Joseph Dixon, a homeopathic chemist, who also acted as dispenser for the town's Homeopathic Dispensary.

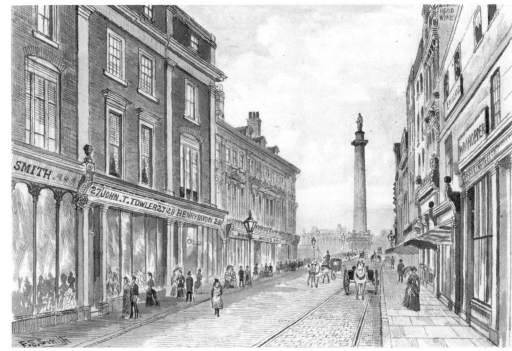

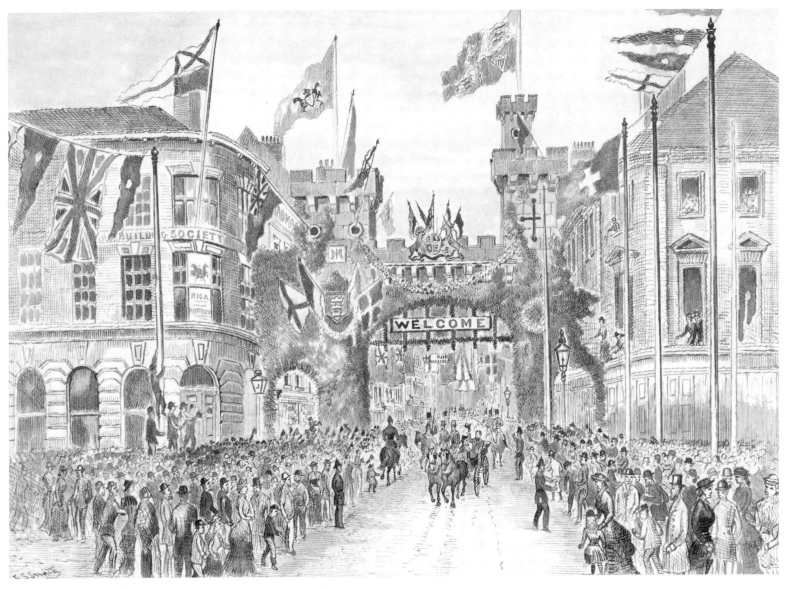

22. Royal Visit, Whitefriargate
(Acc. No. 641.1982.14)

Smith's drawing of the top of Whitefriargate shows the re-constructed 'Beverley Gate' which was erected to decorate the street for the visit of the Duke and Duchess of Edinburgh in October 1884. The Duke and Duchess came to Hull to lay foundation stones at the Infirmary, and to open a bazaar in aid of the Seamen's and General Orphan Asylum. The "gate" was built of wood and the bottom part was covered with branches of spruce. According to the *Hull Times* (4 October 1884) the gate had two towers, and "... below the grating, in pink letters, on a white ground, was printed ... the word 'Welcome'." The Russian flag adorned the structure and may be the flag above the left hand tower.

There also appears to be the monogram "M" on this tower; the Duchess of Edinburgh was Marie, the daughter of Tsar Alexander II of Russia. The royal couple were escorted by troops and mounted police and were welcomed by large crowds. The name "Tadman" appears on the building behind the left hand tower. This was the *Andrew Marvel* public house, whose landlord at the time was Henry Tadman.

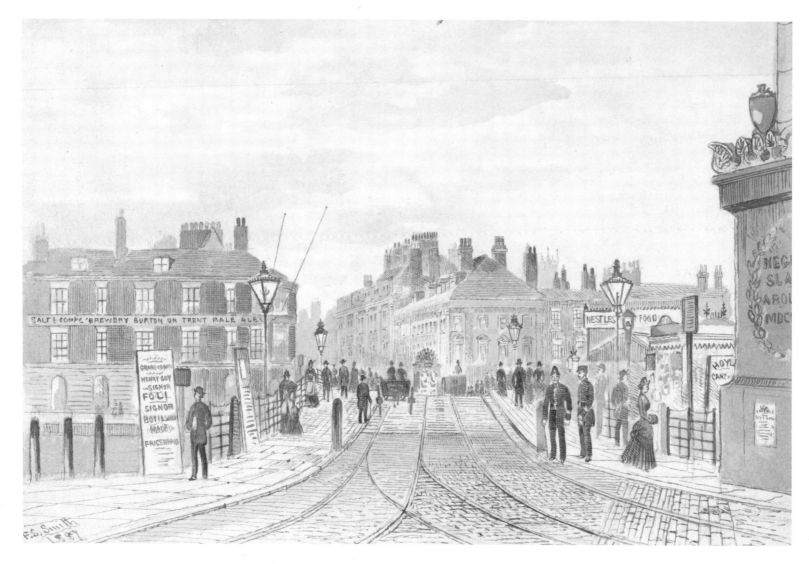

23. Monument Bridge, looking towards Whitefriargate, 1887
(Acc. No. 367.1929)
Sponsored by Ove Arup & Partners Scotland

Monument Bridge formed one of the links between the man-made island of the Old Town and the other parts of Hull. The bridge crossed the lockpit between Queen's Dock and Prince's Dock and could be raised to let ships pass. The bridge gained its name from the monument to William Wilberforce which stood by the side of the lockpit. Part of the monument can be seen at the right of Smith's drawing. It was built in 1834-1835 and the cost — £1,250 — was met by public subscription. The monument was moved to the east end of Queen's Gardens in 1935. The tramrails running across Monument Bridge can be clearly seen. Horse tramways were laid after 1872 when the Continental and General Tramway Company of London was empowered to lay lines. In 1875, the Hull Street Tramway Company was formed, which took over from the older company, before being bought by the corporation in 1895. Electrification of the tramways took place in the late 1890s. The swing bridge over the lockpit was in constant use and caused frequent disruption to traffic.

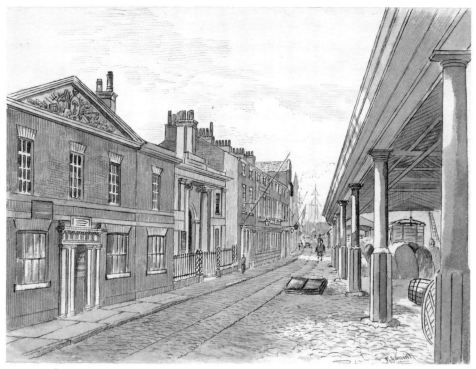

24. Prince's Dock Side, c.1885
(Acc. No. 88.1929)
Sponsored by the Corporation of the
Hull Trinity House
Smith's sketch of Prince's Dock Side
shows the street when it was an active
cargo handling area. The entrance to
Trinity House buoy yard is through
the 'Doric' gateway on the left.

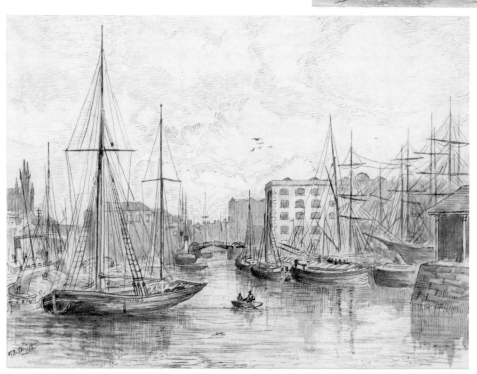

25. Prince's Dock looking south to
Mytongate Bridge, c.1885
(Acc. No. 389.1929)
Sponsored by Hugh Martin Partnership
This view of Prince's Dock shows the
bridge over the lockpit between
Prince's Dock and the Humber Dock.
The dock is crowded with shipping,
including, on the left, a fishing smack.

26. The Mariners' Church, Prince's Dock Side, 1883
(Acc. No. 259.1929)
Sponsored by Peat Marwick McLintock – Chartered Accountants

The Mariners' Church opened in 1828 in a former Non-Conformist chapel. A new church was built, of brick with an Early-English style facade, which opened in 1834. The church had no side windows but was lit partly from the glass lantern on the roof ridge, and contained galleries around the nave which provided seating for 1,100 people. It was reputedly the first Mariners' Church established in England. The Mariners' Church Society was founded shortly before the church was opened. It ran a mission to sailors in the port, organised night classes for seamen and ships' apprentices in winter, where reading, writing, arithmetic and some navigation were taught, and founded a Sailors' Orphan Society in about 1855. The Hull Seamen's and General Orphan Asylum was built in 1865-1866 to accommodate 100 children, predominantly the children of seamen. By 1890, 202 children were resident in the home and other orphans living with relations in the town were supported. On the left of the drawing is a crane for loading and unloading vessels.

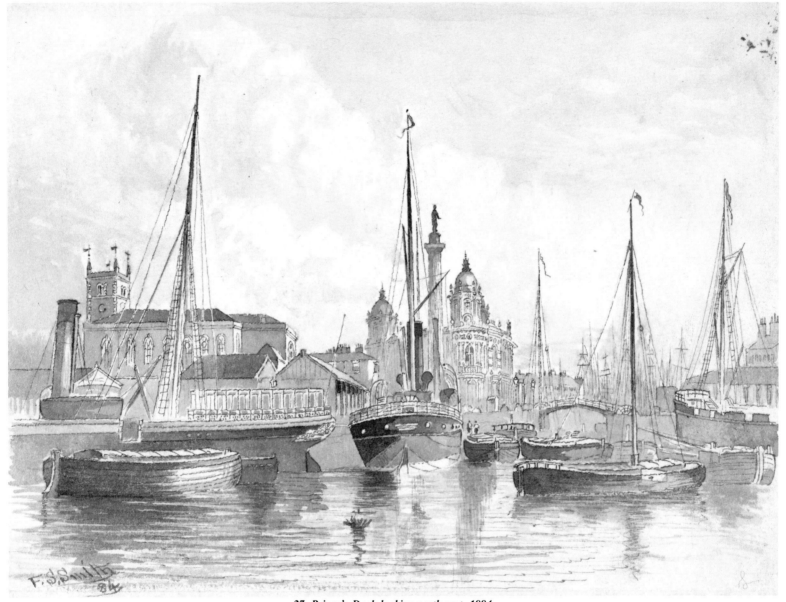

27. Prince's Dock looking north-east, 1884
(Acc. No. 382.1929)
Sponsored by Hugh Martin Partnership

Prince's Dock was the third of the town docks to be built. It opened in 1829 and provided the link between Queen's Dock and Humber Dock, so that ships could sail through the docks from the Humber to the Hull. The original name of the dock was Junction Dock. Smith's drawing shows the north end of the dock, with St. John's Church, Wilberforce Monument, Monument Bridge and the Dock Offices, now Town Docks Museum.

The ships in the dock include steam ships and Humber sloops and keels. Fishing smacks also used the dock. The fishing industry developed in the first half of the 19th century. Although the fishing industry was profitable it was also very dangerous — in March 1883, 180 men lost their lives at sea. The high number of casualties often caused poverty and hardship for families in the town; in the mid 19th century, one third of the widows and orphans in Hull were of seamen lost at sea.

28. Posterngate looking east, c.1885
(Acc. No. 70.1929)
Sponsored by J.R. Rix & Sons Ltd – Shipowners, Shipbrokers,
Petroleum Distributors
Posterngate gained its name from the postern or small gate in the
town walls, which stood at the end of the street. Smith's drawing
shows Trinity House Almshouse on the left. On the extreme right
is the Shipping Office public house.

29. Dagger Lane looking south, c.1885
(Acc. No. 44.1929)
The sketch of Dagger Lane was made
from a viewpoint south of Robinson
Row, looking down to Mytongate.
The building on the south side of
Mytongate is the *Turk's Head* public
house, whose landlord in 1885 was
Nils Jonsson.

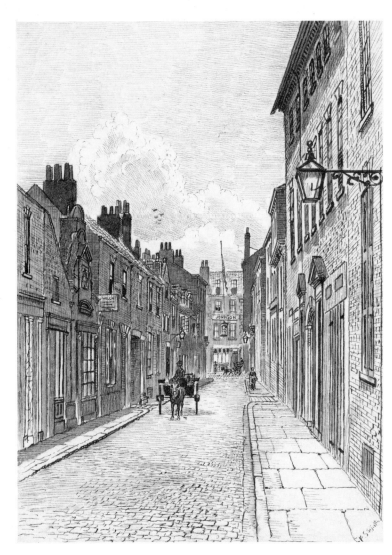

38

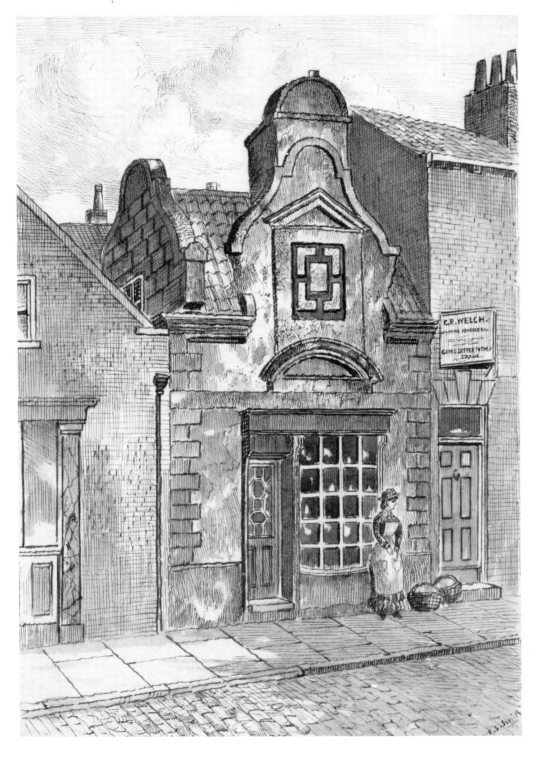

30. Old House, Dagger Lane, c.1888
(Acc. No. 350.1929)
The Old House, which was demolished in 1943, formerly stood on the east side of Dagger Lane. It was built in the 17th century, largely of brick, and was dominated by the double-tier Dutch gable. The ground floor had been altered and had a late Georgian shop-front. The house was used as a shop in the 19th century — in 1888 it was a boot and shoe-makers. No.11 Dagger Lane, the house next door, was occupied by Charles Welch. His sign, illustrated by Smith, described him as a working jeweller and gemsetter to the trade.

31. Weaver's Hospital, Dagger Lane, 1888
(Acc. No. 281.1929)
The almshouse in Dagger Lane, the Weaver's Hospital, was
founded by a weaver, Peter Simpson, and endowed by John
Buttery in 1775. The almshouse was consolidated into the
Municipal Hospitals in 1887, and the building was sold and
later demolished.

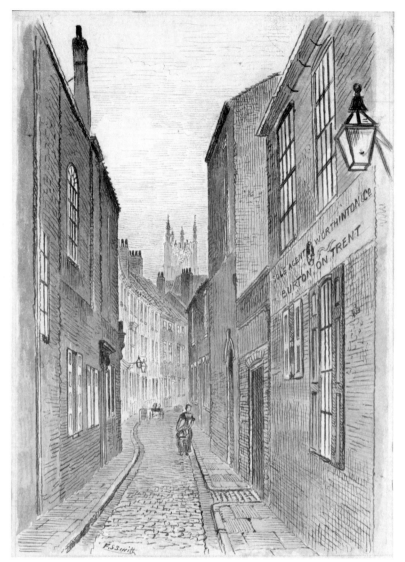

32. Prince Street, from Dagger Lane
(Acc. No. 45.1929)
Prince Street was developed c.1771 by the Hull architect
Joseph Page. Smith's drawing shows the view down the street,
looking east to Holy Trinity. The second building on the right
is a masonic lodge, the Minerva Lodge, which opened in 1802.

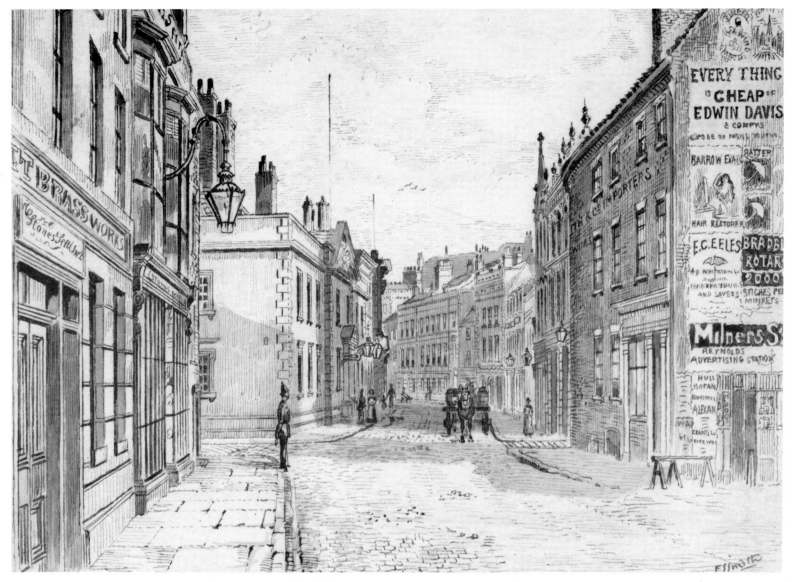

33. Trinity House Lane looking north, c.1885

(Acc. No. 73.1929)

Sponsored by the Corporation of the Hull Trinity House

Smith's viewpoint for this drawing is King Street, just south of the crossroads with Posterngate, North Church Side and Trinity House Lane. Trinity House stands on the corner of the street opposite the *Kingston Hotel*. Trinity House was remodelled and rebuilt in the 18th century; the principal front on Trinity House Lane was rebuilt in 1753-1759 in brick with stone dressings (the brickwork was stuccoed in 1828). The carving above the main entrance is by Jeremiah Hargrave and depicts the Royal Arms supported by Neptune and Britannia.

The advertisements on the side of the building in King Street promote various businesses which had premises in the town. Batters, and Eeles, two umbrella manufacturers, had premises in Waterworks Street and Whitefriargate respectively; Singer Sewing Machines were supplied by the company's agent, George Thewliss, in Whitefriargate; and Edwin Davis and Co., drapers, furnishers and outfitters, had premises in a block on the south side of Holy Trinity.

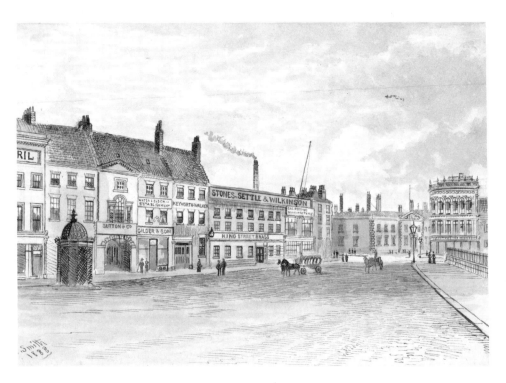

34. King Street, 1888
(Acc. No. 39.1929)
The street at the west end of Holy
Trinity was improved in the 1770s
when it was renamed King Street. In
1888 10½ King Street was occupied
by Gilder and Son, pawnbrokers, and
the three golden balls of a
pawnbroker are illustrated.

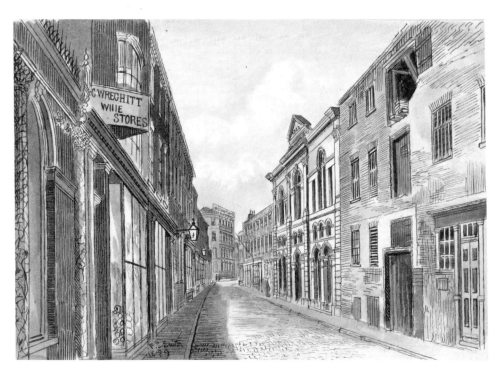

**35. Fish Street looking north to King
Street, 1889**
(Acc. No. 243.1929)
*Sponsored by Kingston
Communications (Hull) plc*
Fish Street Congregational Chapel is
depicted on the right of the drawing.
Protestant non-conformity developed
in Hull in the mid 17th century and
by the 19th century there were many
non-conformist congregations in the
town.

42

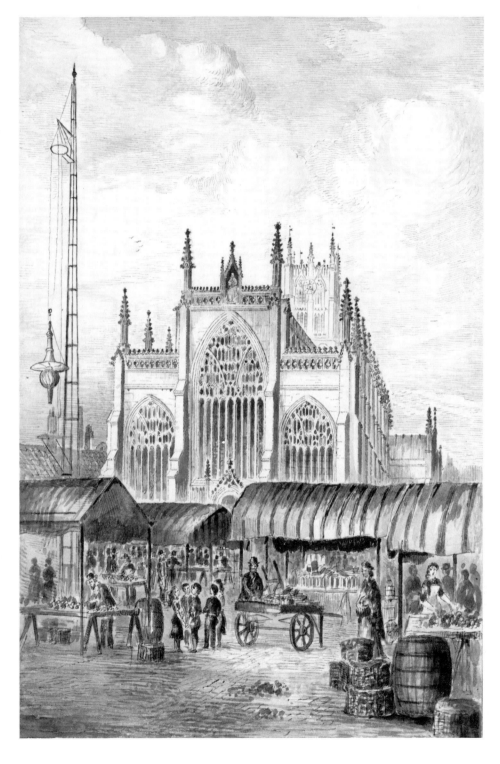

36. Holy Trinity Church and the Market

(Acc. No. 415.1981.22)

Sponsored by Peat Marwick McLintock – Chartered Accountants

Holy Trinity Church, stands on the site of at least one earlier chapel. The transepts of the present building date from c.1290. The church contains some of the earliest surviving medieval brickwork in the country and is the largest parish church (by area) in England. Holy Trinity was an outlying chapel of the parish of Hessle and only became a separate parish in 1661, although some parochial rights had been granted as early as 1301. Smith's sketch shows the market at the west end of the church, crowded with stalls and thronged with people.

The lamp fixed to a pylon on the left of Smith's drawing is an electric arc lamp. Electric lighting was first used in the streets of Hull in 1882. The carbon rods of the arc lamps, however, burnt out very quickly and therefore in 1884 the system was abandoned and street lighting reverted back to gas lamps.

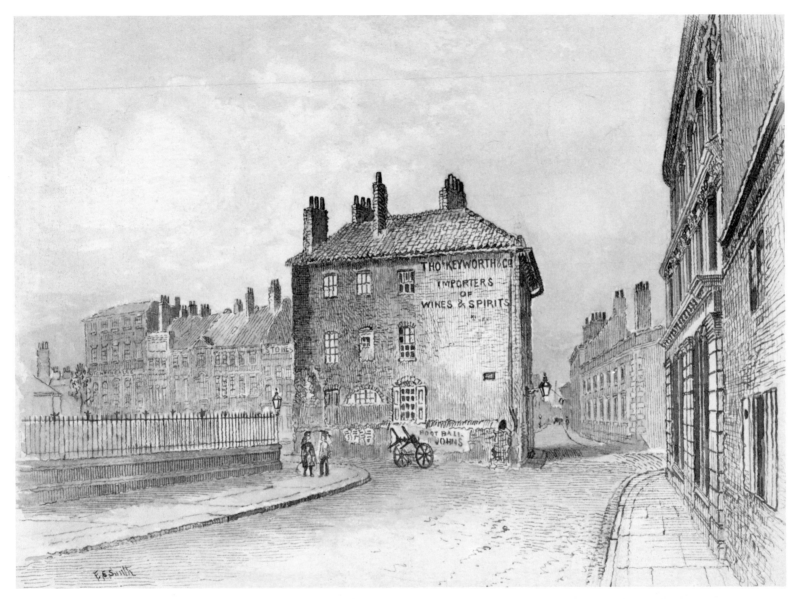

37. Posterngate and King Street from North Church Side, c.1885
(Acc. No. 224.1929)

Thomas Keyworth & Company, wine and spirit importers, occupied Nos. 1 and 2 King Street, the only premises (apart from the church) on the south side of the street in the early 1880s. Smith's viewpoint is from North Church Side, just before the *Kingston Hotel*. Holy Trinity Churchyard is on the left-hand side and Posterngate is directly ahead. Part of the almshouse on North Church Side is also visible. In the late 14th century an almshouse next door to Holy Trinity Churchyard was endowed by Robert de Selby and his wife and Richard de Ravenser. This almshouse may have been the dilapidated building on North Church Side which was rebuilt in 1708. The repairs were paid for by Thomas Watson, the Bishop of St. Davids, who was born at North Ferriby and educated at Hull Grammar School, and the almshouse was endowed by his brother William in 1721. The hospital was replaced in 1887 by new almshouses in Northumberland Avenue.

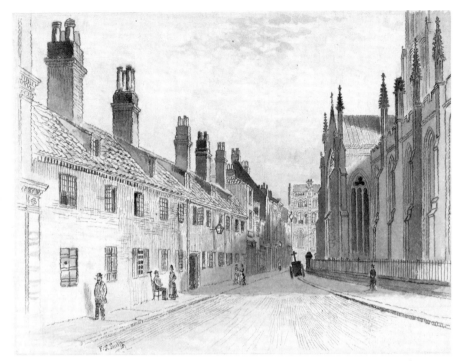

38. North Church Side, looking towards the Market Place
(Acc. No. 68.1929)
Watson's Hospital on North Church Side has been demolished and the site is now occupied by the Market Hall, which opened in 1904.

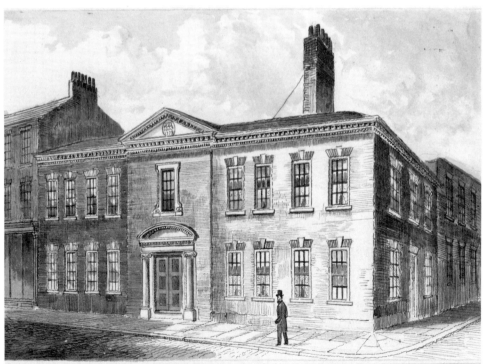

39. Lister's Hospital, South Church Side
(Acc. No. 288.1929)
Sir John Lister, who made provision for the almshouse in his will of 1640, was a prominent Hull citizen, MP for the town and successful merchant. Lister's Hospital was conveyed to Edwin Davis in 1869 and the building was later demolished.

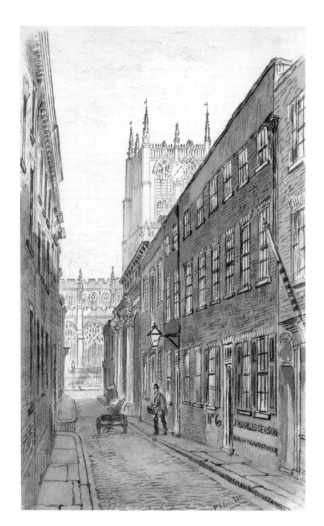

40. Vicar Lane, looking towards Holy Trinity, c.1885
(Acc. No. 50.1929)
Vicar Lane was the site of the Vicar's School, Hull's first public elementary school. The school was founded by the vicar of Holy Trinity and some tradesmen in 1730, and taught reading, writing and Christianity to poor children.

41. Crowle's Hospital, Sewer Lane, 1888
(Acc. No. 286.1929)
Sponsored by English Estates
Crowle's Hospital was founded by George Crowle in 1661. The hospital was one of the Municipal Hospitals consolidated in 1887, when new almshouses were built outside the Old Town. Sold in 1902, the hospital was later demolished.

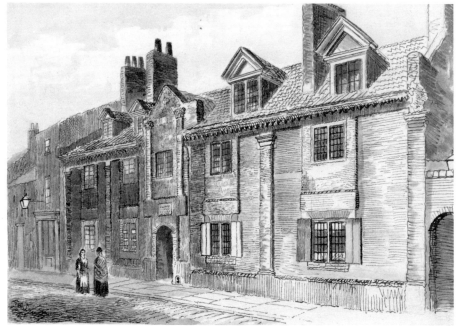

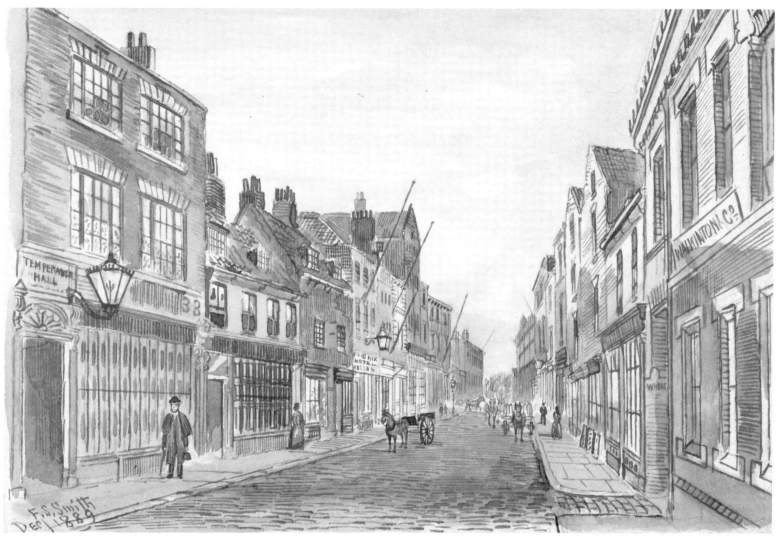

42. Mytongate looking west to Mytongate Bridge, 1889
(Acc. No. 109.1929)
Sponsored by Marsden Builders Ltd.

This drawing depicts Mytongate, west of Fish Street, and looking west to Mytongate Bridge. The premises on the right of Smith's sketch are those of Walkington & Ombler, stationers, beyond which is the *Tiger No.4* public house. Almost opposite the pub is Lodge Entry down which the Temperance Hall was situated. Sheahan described the hall as "... large and commodious..." and stated that it had been built by the Freemasons in 1800 as the Rodney Lodge.[5] The Temperance Movement in Hull began in the 1830s and increased its membership throughout the century. Temperance services and collections were held in the town's churches and chapels, lectures were given on the subject, marches were held in the town, and temperance galas were held in the Zoological Gardens on Spring Bank. Despite these activities heavy drinking continued to be a problem in the town throughout the 19th century.

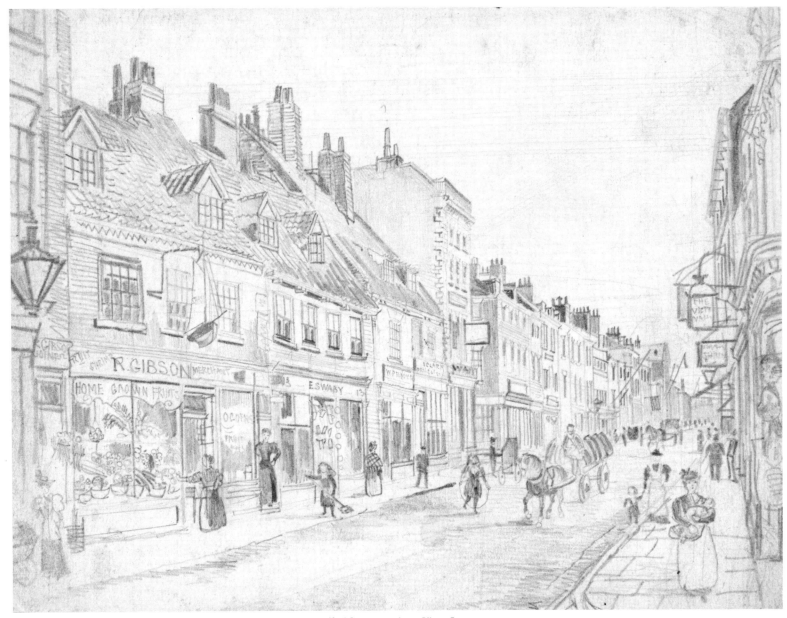

43. Mytongate from Vicar Lane
(Acc. No. 411.1929)
Sponsored by Marsden Builders Ltd.

This drawing shows Mytongate, looking westwards from Vicar Lane, around the turn of the century. The public house on the right is the *Victoria* and on the opposite side of the road are the premises of Robert Gibson, a joiner and fruiterer who also sold shrimps, presumably the reason why there is a boat hanging above the shop-door. William Pedder, at No.14 Mytongate, was a tripe dresser, one of the town's "offensive trades". The "offensive trades", which included tanning, glue-making and varnish boiling, caused appalling smells and fumes, and these businesses were often blamed for health problems and disease in Hull. Some of the blame was justified, but the unsanitary courts behind main streets such as Mytongate also provided good breeding grounds for diseases.

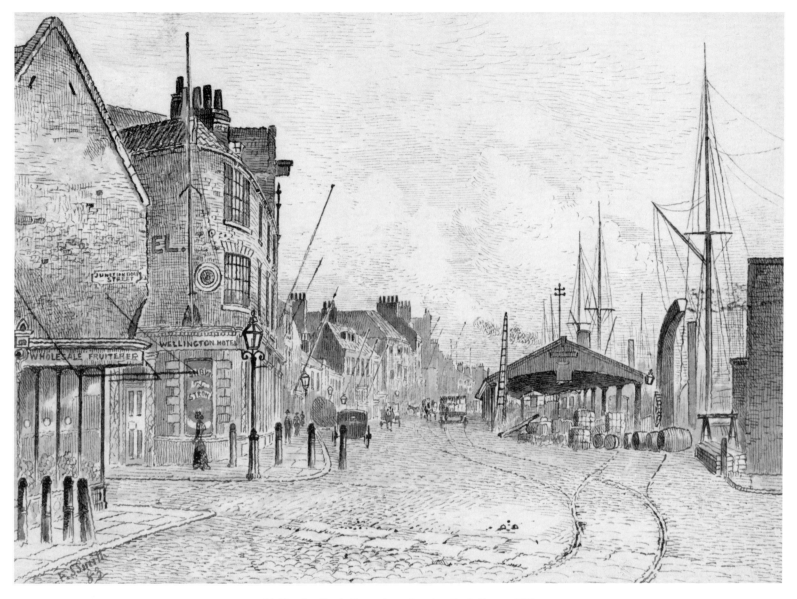

44. Humber Dock Street from Junction Dock Street, 1883
(Acc. No. 377.1929)

Smith's view-point for this drawing is the bottom of Junction Dock Street, looking over Mytongate to Humber Dock Street. Junction Dock was the original name of Prince's Dock. The masts of the crowded shipping in Humber Dock can be seen in the sketch. By the 1880s the port was becoming congested and new docks were constructed during the late 19th and early 20th centuries to accommodate the vessels, for example St. Andrew's Dock, which was used by fishing boats, opened in 1883, the year Smith executed this drawing. Humber Dock was the second of the town docks to be built. The dock was designed by John Rennie, possibly the greatest dock engineer of the period, and opened in 1809. The dock closed to shipping in 1969 and was re-opened as a marina in 1983. Goods were carried to and from the dock by railway or horse-drawn transport, and railway lines and horse drawn rullies (flat wagons) are depicted in the sketch.

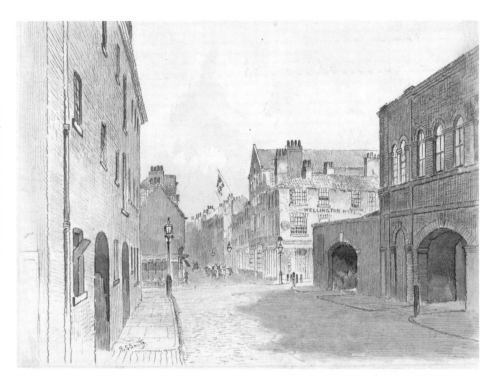

45. Castle Street looking east across Mytongate Bridge towards Mytongate, c.1885
(Acc. No. 46.1929)
This drawing was made from a viewpoint in Castle Street next to No. 6 Warehouse, west of Mytongate Bridge with the corner of Prince's Dock Side on the left and Humber Dock Side on the right. The *Wellington Hotel* stood on the corner of the two streets. The building on the right, Alexandra Chambers, was used as offices.

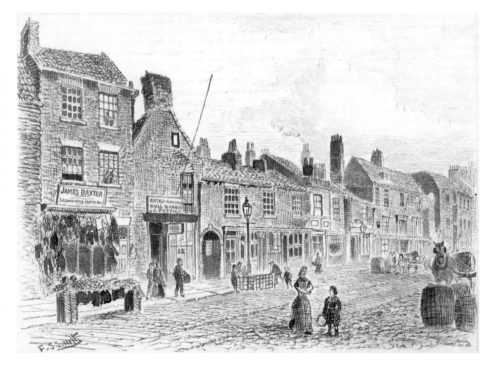

46. Humber Dock Street, looking south, c.1885
(Acc. No. 86.1929)
Humber Dock Street was one of the poorer streets in Hull. This is illustrated by the clothes of the women depicted — instead of fashionable dresses and hats, they wear plain skirts, shawls and aprons, and one is bare headed.

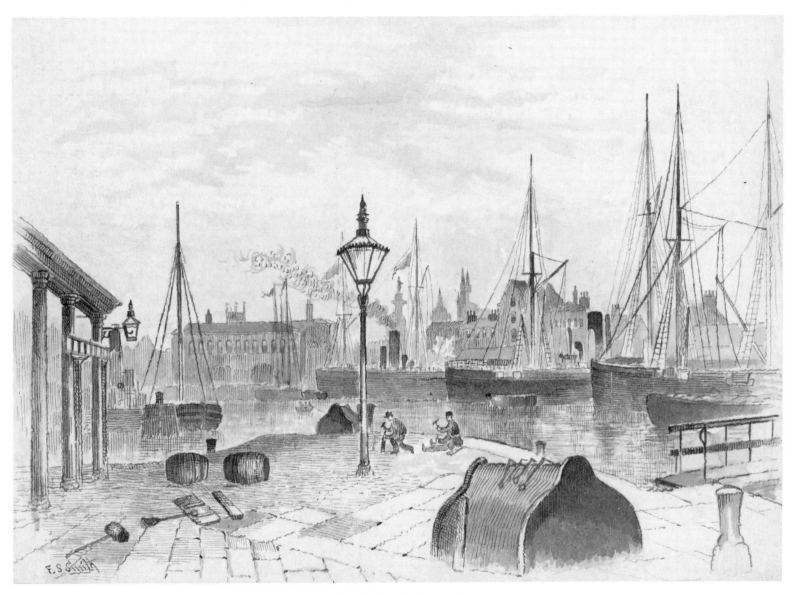

47. Humber Dock, c.1885
(Acc. No. 399.1929)

This is Humber Dock in its heyday. The artist drew the dock from the western side of the lockpit between the dock and the dock basin. The saddle-shaped objects in the foreground and behind the lamp-post contained the machinery for moving the lock-gates; the winding handles can be seen resting on the top of the case in the foreground. Various trading ships are moored in the dock, among them a steamer of the Bailey and Leetham line with the characteristic white 'tomb stone' on its funnel, and mooring posts can be seen along the edge of the dock. There is also a 'dolphin', for mooring in the middle of the dock, depicted beyond the shed on the left. Several of Hull's landmarks can be seen in the distance. On the left of the drawing the tower of St. John's Church is visible (the site is now occupied by the Ferens Art Gallery): moving to the right are Wilberforce Monument, one of the domes of the Dock Offices (now Town Docks Museum), and the turrets of the Mariners' Church on Prince's Dock Side.

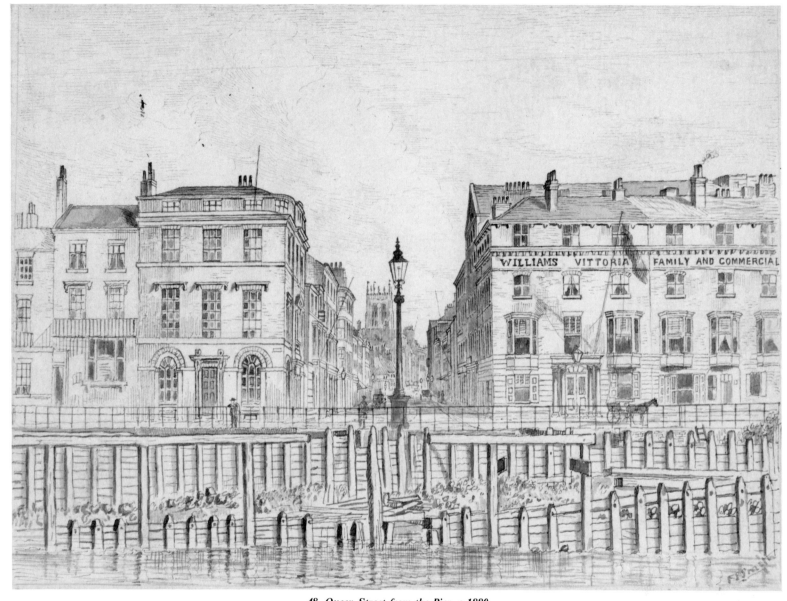

48. *Queen Street from the Pier, c.1880*
(Acc. No. 27.1929)
Sponsored by Radius Systems Ltd

The medieval walled town had covered a smaller area than the 19th century Old Town. The Humber originally flowed at the foot of the town walls, which had run along the south side of the road later known as Humber Street. During the 18th century silting had built up a foreshore and in the early 19th century this was extended and more land reclaimed by dumping soil excavated from Humber Dock on the site. Streets were laid out on the new ground, two of which were named after military heroes of the period — Nelson Street commemorated Lord Nelson, killed at Trafalgar in 1805, and Wellington Street was named for the Duke of Wellington, hero of the Peninsular Wars. The streets were named in 1813, the year of Wellington's victory at Vittoria, and this may be the origin of the name of the *Vittoria Hotel*. The lamp in the centre of the drawing is probably the handsome "... Ionic gas pillar... " erected in 1822 to guide ships into the harbour.[6]

49. Victoria Pier and Nelson Street, looking west, c.1885
(Acc. No. 26.1929)
The Humber ferry, which, until 1897, was operated by the Manchester, Sheffield and Lincolnshire Railway, sailed between the Victoria Pier and New Holland. The company's offices, surmounted by a clock, are depicted in Smith's sketch.

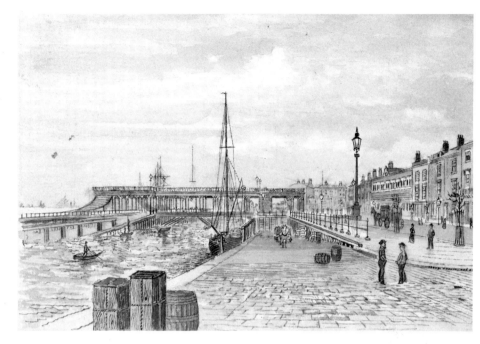

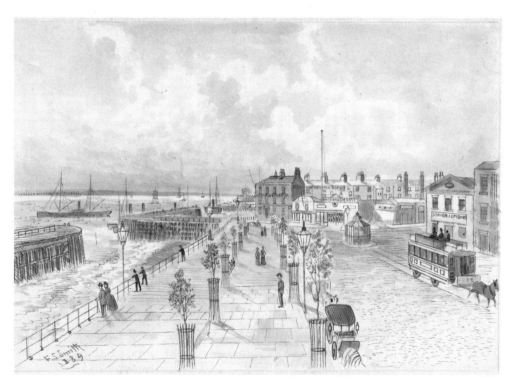

50. Nelson Street looking west, 1889
(Acc. No. 29.1929)
The vehicle on the right is a horse-drawn tram, one of the forms of public transport in 19th century Hull. In the centre of the sketch carriages for hire wait at a cab-stand.

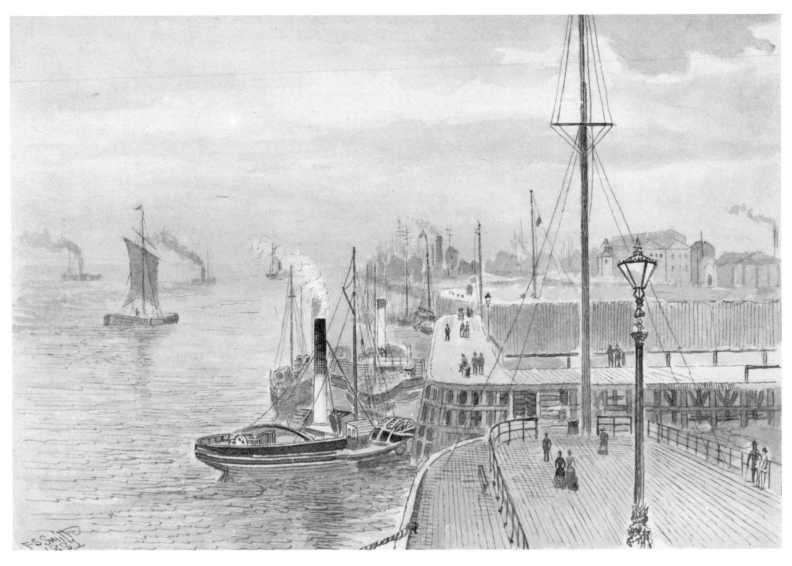

51. River front from the Pier, looking west, 1887
(Acc. No. 381.1929)

Victoria Pier was a popular place to promenade in late 19th century Hull and Smith's sketch shows several people taking the air and admiring the view. The viewpoint of the drawing is the west end of Victoria Pier looking towards East Pier (the pier near the *Minerva Hotel*) and westwards along the Humber shore where Albert, William Wright and St. Andrew's Docks lay. Various ships are depicted in the drawing, including a Humber keel and, by the pier, passenger steamers and a paddle tug.

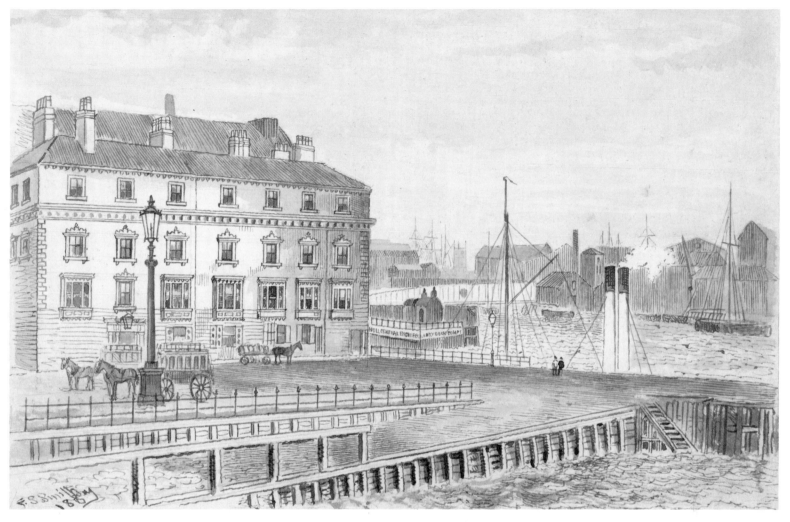

52. The entrance to the Old Harbour and the Vittoria Hotel, 1887
(Acc. No. 30.1929)
Sponsored by Radius Systems Ltd

The Haven (the River Hull from North Bridge to the mouth) formed a safe anchorage for shipping on the Humber and had been used from at least the 12th century and probably earlier — the original name of the town, 'Wyke' may have derived from the Scandinavian work 'vik', a creek (hence 'viking').

The drawing depicts part of the landing slip by Victoria Pier with the *Vittoria Hotel* behind. Two horse drawn omnibuses and a ladened rully stand in front of the hotel. The entrance to the dry dock of the ship-building company, the Hull Central Dry Dock and Engineering Works Limited, can be seen on the river bank. There were several shipyards in 19th century Hull. Large scale iron ship-building had been introduced in mid-century by Martin Samuelson, an engineer. His yard had been on the east bank by the river mouth, just outside the area illustrated, but although the company closed in 1866 (Samuelson had sold out in 1864) the site continued to be known as 'Sammy's Point'.

53. Queen Street looking north, 1888

(Acc. No. 38.1929)
Queen Street was named for Charlotte, the wife of George III. The road ran from the southern end of Market Place to Nelson Street and replaced the earlier street known as the Butchery, where the meat market was held. Smith's drawing shows the view from Nelson Street with Holy Trinity in the distance and the Pilot Office, designed by John Earle and built in 1819-1820, on the left. The office was built of brick with stone dressings and was domestic in scale and detail, distinguished only by the inscription.

The Humber estuary is a dangerous stretch of water with many sandbanks and strong currents. The responsibility for piloting ships in and out of Hull had been granted to Trinity House in 1512, and the Brethren had the monopoly of Humber pilotage (and dues) until the beginning of the 20th century, when pilotage was transferred to the Humber Conservancy Commissioners.

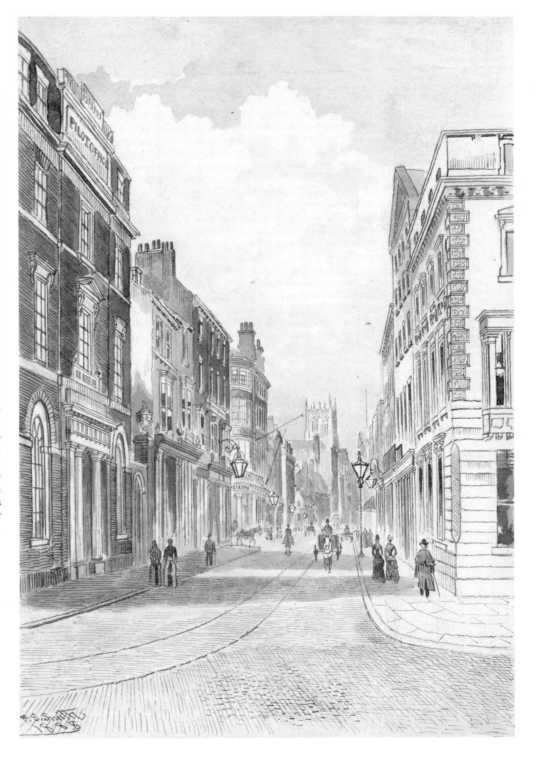

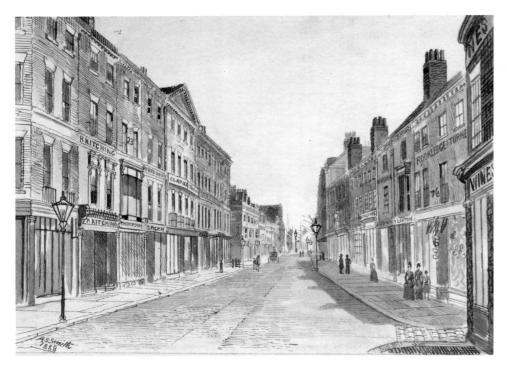

54. Queen Street looking south from Blanket Row, 1888
(Acc. No. 31.1929)
This drawing was made from a point just north of Blanket Row. The building at the extreme right is the *Golden Lion* public house and the cobbled street beside it is Blanket Row.

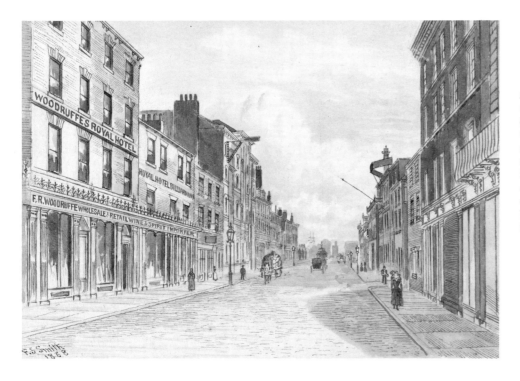

55. Wellington Street looking west from Queen Street, 1888
(Acc. No. 36.1929)
Cobbles were used to pave streets in Hull from the 14th century. The stones were often loosened by frost and were difficult to keep clean. In c.1824 Wellington Street became the first road in Hull to be macadamised.

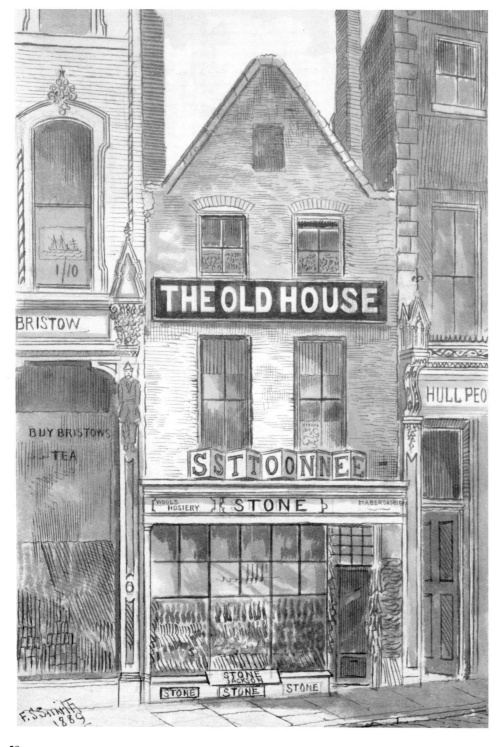

56. The Old House, Queen Street, 1889

(Acc. No. 348.1929)

The three buildings shown in Smith's drawing stood between Blanket Row and Mytongate. The shop front of No.84, the premises of Bristow and Company, grocers and tea merchants, was designed in 1874 by W.H. Kitchen; the decoration around the shop window, partially illustrated by Smith, included carvings of Chinese men (China was a tea producing country). No.85 Queen Street was the hosiery shop of Edward Stone and next door to the 'Old House' was a cocoa and coffee house belonging to the Hull People's Public House Company. The company was founded by temperance supporters to provide working people with an alternative to public houses, by providing non-alcoholic drinks in pleasant surroundings. The *Cocoa Houses* were opened near the work places and homes of working people although in the 1880s the company diversified and built temperance cafés and hotels in other parts of the town. The organisation was profitable and popular but it did not radically alter drinking habits in Hull; in 1889 the *Cocoa Houses* catered for probably 3,000 people per day, less than 10% of the number catered for by the town's public houses.

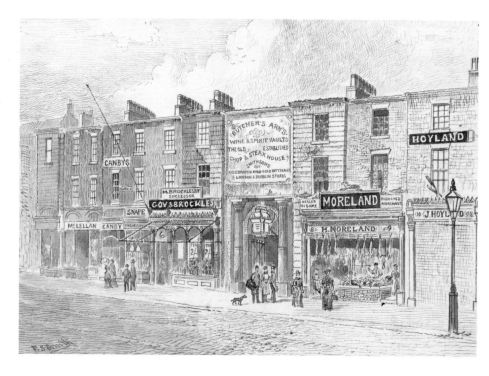

57. The Old Shambles, Queen Street, c.1882
(Acc. No. 42.1929)
Smith's drawing shows the street frontage of the Butchers' Shambles, "... a very plain building in Queen Street, occupying the site of the Black Friary and the old Guild Hall ...", from the corner of Fetter Lane to No.10 Queen Street.[7]

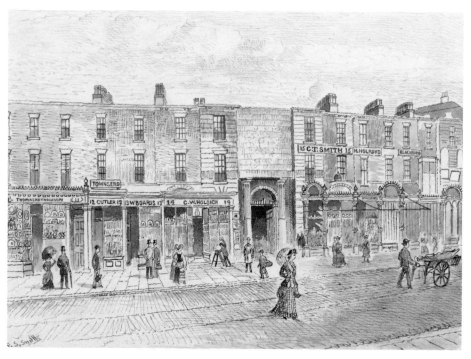

58. The Butchers' Shambles, Queen Street, c.1882
(Acc. No. 127.1929)
The depiction of the Butchers' Shambles is continued in this drawing, which shows the frontage from No.11 Queen Street, the premises of Thomas Reynoldson and Sons, jewellers, to the corner of Blackfriargate.

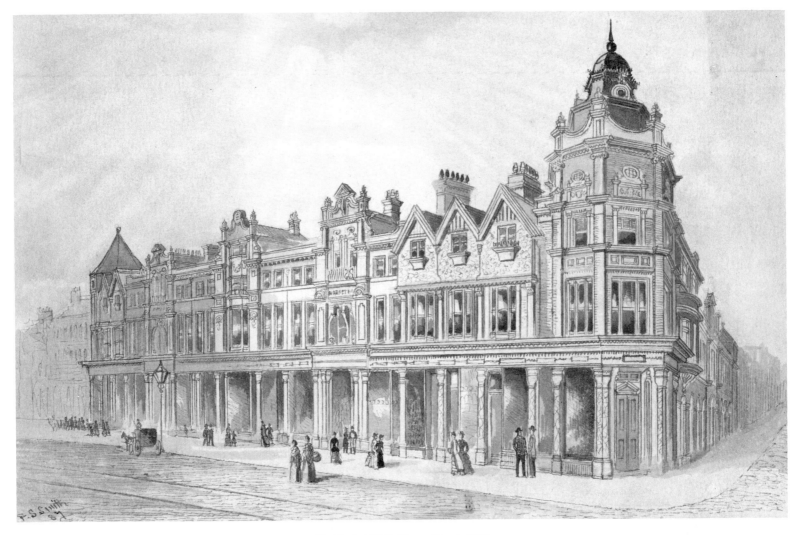

59. Market Hall, Queen Street, 1887
(Acc. No. 415.1981.24)
Sponsored by Kingston Communications (Hull) plc

A meat market in the Butchery was mentioned as early as 1337. The Butchery was a street at the southern end of Market Place, entered through an archway between the old Guildhall and the prison, and meat was sold there until the 17th century. In 1762 butchers' shambles were built in the area; they were enlarged and rebuilt in 1806 and the building is illustrated in Drawings 57 and 58. In 1887 the shambles were replaced by a Market Hall,

...designed in the Flemish Renaissance style, with a septagonal pavilion tower at the south-west corner, and an octagonal tower at the north-east corner. It is faced with red brick, with Ancaster Stone dressings. The Queen Street frontage consists of fourteen shops ... The north, south and east sides are occupied by butchers' shops, lined with white glazed bricks.[8]

The building, drawn by Smith in the year in which it opened, was destroyed by bombing in 1941.

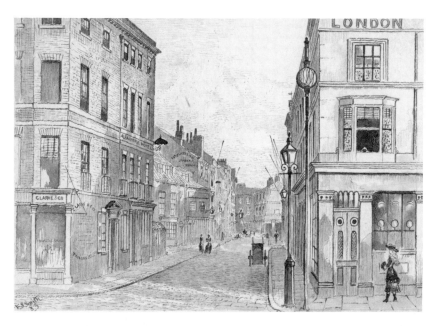

60. Humber Street looking east from Queen Street, 1883
(Acc. No. 34.1929)
This sketch was made from a viewpoint at the intersection of Queen Street and Humber Street, looking east towards High Street. An electric arc lamp stands by the *London Hotel.*

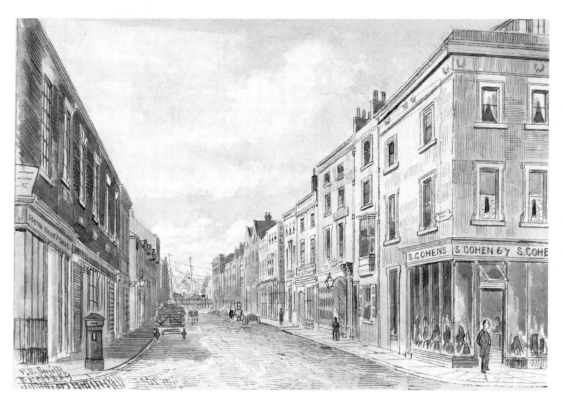

61. Humber Street looking west from Queen Street, 1889
(Acc. No. 41.1929)
Sponsored by Consolidated Fruit Co. Ltd.
A view of Humber Street looking towards Humber Dock. A theatre stood at the south-west corner of Queen Street and Humber Street in the early 19th century; it was known by various names including the Minor Theatre.

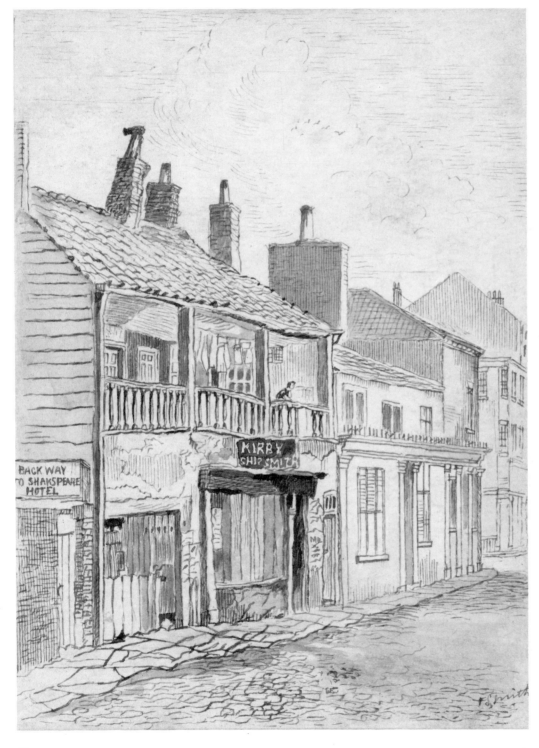

62. Pier Street looking south with the Granby (and Lincolnshire) Hotel at the corner of Wellington Street on the right.
(Acc. No. 35.1929)
The passage on the left giving access to the rear of the *Shakespeare Hotel* in Humber Street ran between the Wesleyan chapel and Kirby's shipsmith's premises shown by Smith. The *Shakespeare Hotel* was situated on the south side of Humber Street, east of Pier Street, and these properties, near the back entrance to the public house, probably stood in the area between Humber Street and Wellington Street. Several pubs in the Old Town had back entrances into areas of court housing, and they provided havens from the squalid living conditions endured by many people. Houses built in the preceding centuries had often degenerated into slums by the 19th century. The galleried building, which seems to have been used as housing and business premises, appears to have poor woodwork and cracking plaster; inside it would probably have been cold, damp and verminous.

63. Brick archway, Humber Street, c.1885
(Acc. No. 20.1929)
Sponsored by Kingston Communications (Hull) plc

The building with the archway stood on Humber Street at the entrance to Little Lane, an alley running between Humber Street and Blackfriargate. There had formerly been a jetty and landing stairs on the Humber bank in this area (the estuary had originally flowed at the foot of the town walls which ran along the line of Humber Street) and Little Lane had been an ancient passage into the heart of the Old Town.

To the right of the building pierced by the archway was the *King William* public house; the name of the landlord, George Pickwell, may be seen above the door; and to the left was the *Tiger No.6* public house, formerly called the *Labour in Vain*. This was used in the 18th and 19th centuries by the press gang, who forcibly enlisted men into the navy.

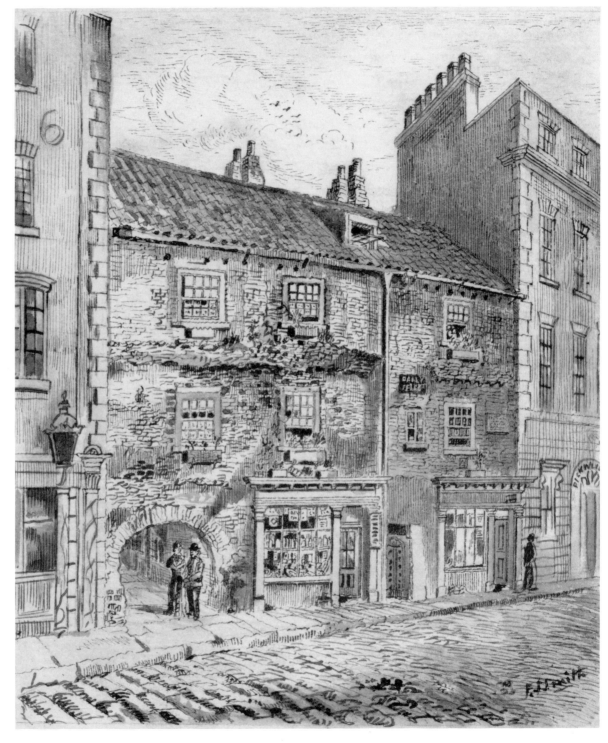

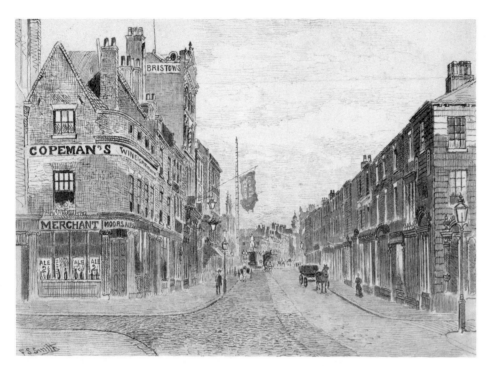

64. Queen Street looking north from Blackfriargate, c.1883
(Acc. No. 49.1929)
This drawing was made from the intersection of Blanket Row, Blackfriargate and Queen street, looking north to Market Place. The *Cocoa Rooms* flag is visible on the left and 'King Billy' can be seen in the distance. The *Golden Lion* on the left was destroyed during a Zeppelin air raid in March 1916.

65. Market Place looking north, c.1883
(Acc. No. 52.1929)
The drawing shows the west side of Market Place and the east end of Holy Trinity Church. The shop near the corner of South Church Side was Edwin Davis' store, bombed in Zeppelin raids during the First World War (1914-1918).

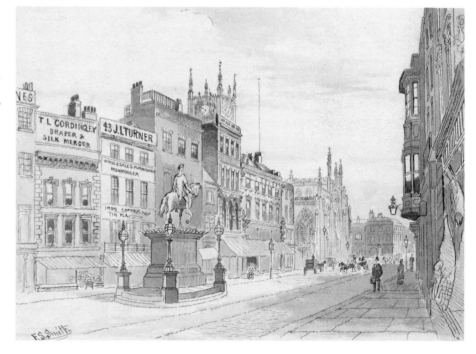

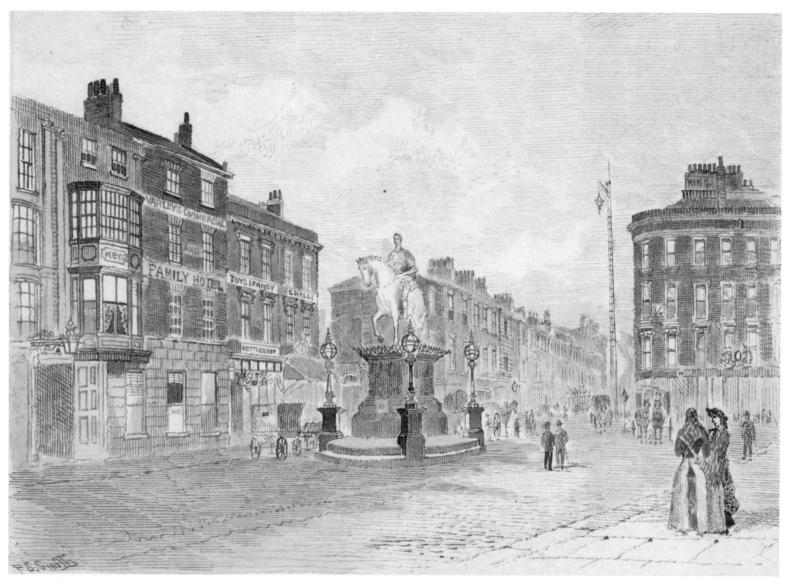

66. Market Place looking south c.1883

(Acc. No. 48.1929)

Sponsored by Kingston Communications (Hull) plc

Smith's view of Market Place shows the southern end of the street looking south to Queen Street. The statue of 'King Billy' stands in the centre of the street and opposite it is the *Cross Keys* hotel. The *Cross Keys*, probably established in the 1660s, was an important coaching inn in the late 18th and early 19th centuries. It had stabling for over 40 horses and was the departure point for coaches to London and Edinburgh, and for the Hull and York Royal Mail. A horse-drawn delivery van can be seen in front of the hotel. The Hotel ceased trading and had its licence withdrawn in 1923 and the building was demolished in 1937.

Markets were held in Hull from 1279 and by 1293 the market days of Tuesday and Friday had been established; Saturday became a market day in the early 19th century. Specialised markets were held in various parts of the town but the main market was held in Market Place, in an area restricted in 1469 to the street south of Scale Lane and Silver Street. The market supplied Hull's citizens with their food and household requirements.

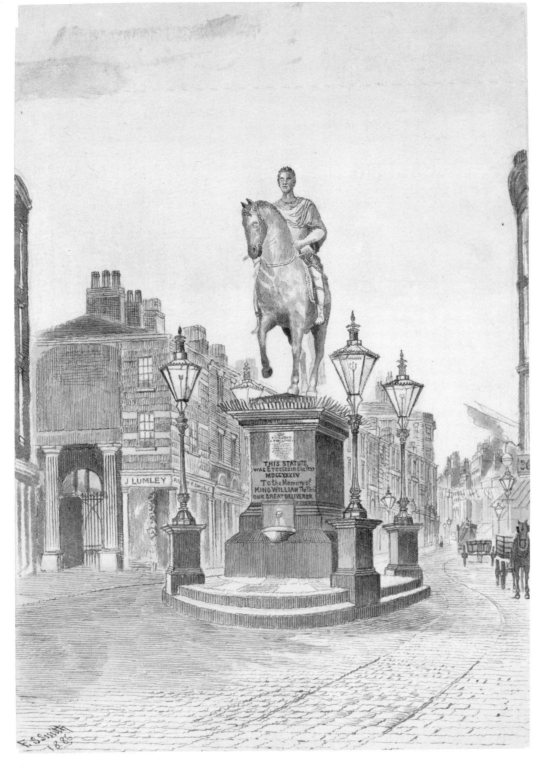

67. The statue of 'King Billy', Market Place, 1886

(Acc. No. 641.1982.19)

The statue of King William III, 'King Billy', was erected by public subscription in 1734 on the former site of the town's bull ring. The statue, originally intended for Bristol, was by the Flemish sculptor Peter Scheemakers, and its composition was influenced by the Roman statue of Marcus Aurelius. The Protestant William of Orange was invited by several prominent citizens in 1688 to take the throne of England from the Catholic James II. Hull's Governor, Marmaduke Langdale, was a Catholic, and he prepared to hold the town for James but he was arrested by the aldermen and citizens and Hull declared for William of Orange.

The position of 'King Billy' in the middle of the street caused an obstruction to traffic. The tram lines had to detour around the statue and therefore the trams in Market Place ran along the only section of double track within the Old Town.

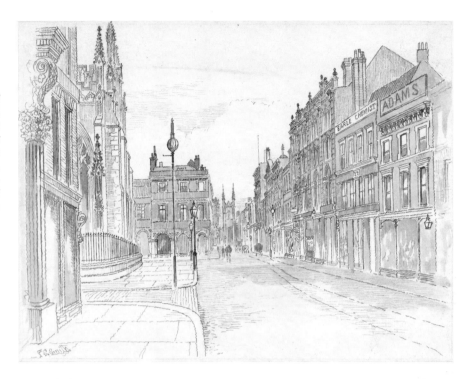

68. Market Place looking north, c.1883
(Acc. No. 69.1929)
Sponsored by Rollit, Farrell & Bladon
– Solicitors
This view of Market Place was made
from a point near South Church Side,
looking north along Lowgate to St.
Mary's Church. The east end of Holy
Trinity can be seen on the left.

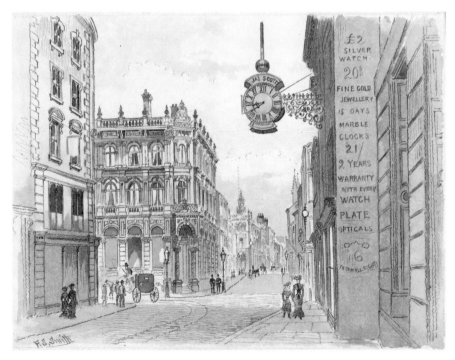

**69. Silver Street corner from Lowgate,
c.1883**
(Acc. No. 65.1929)
The building at the corner of Silver
Street was the premises of the Hull
Banking Company, founded in 1833.
The building "... in the Italian style of
architecture, erected in 1870 ..." is
now a café bar.[9]

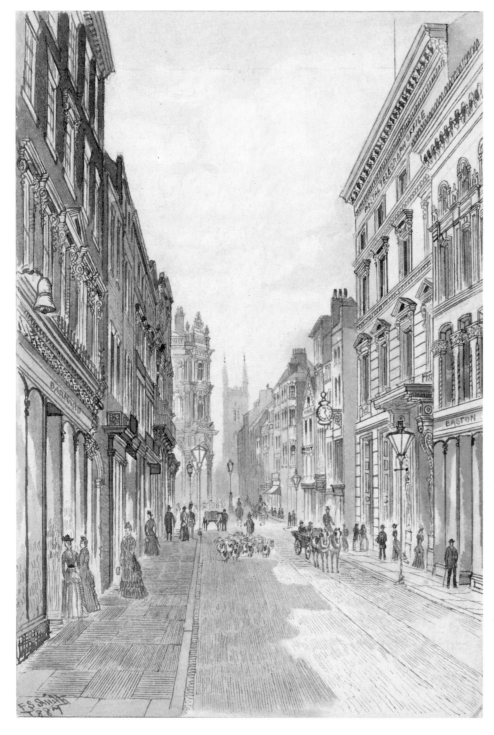

70. Market Place looking north to Lowgate, 1887
(Acc. No. 56.1929)

Sponsored by Royal Mail Letters

The building on the right of Smith's drawing was the Post and Telegraph Office. There was a post office in the town by the early 19th century but the office in Market Place, which opened in 1877, was the first to be owned and maintained by the Post Office. The ground floor was used as a public area and the telegraph room and "... offices for the telephone inter-communication ..." were situated on the second floor.[10] The first telephone exchange in Hull was in operation c.1880. It was run by the Post Office but a rival exchange was opened in 1890 by the National Telephone Company. The City Corporation was licensed to operate a telephone service in 1902. In 1914 it bought the National Telephone Company's plant in the Hull area from the Post Office, and under licence the City Council now operates the only municipal telephone system in the country.

The flock of sheep was probably being taken to the livestock market outside the Old Town or to one of the privately owned slaughter-houses in the Old Town.

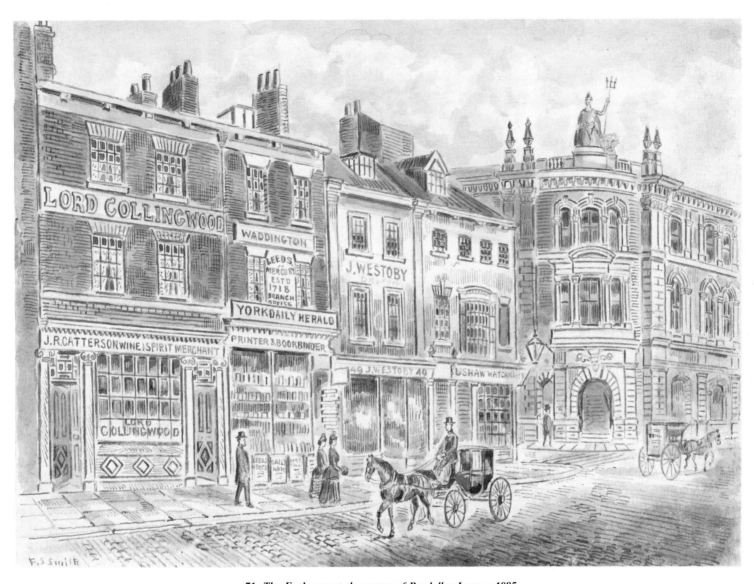

71. The Exchange at the corner of Bowlalley Lane, c.1885
(Acc. No. 19/51.6)

The Exchange on the corner of Bowlalley Lane was built at the cost of £17,000 and opened in 1866. The old weigh-house in High Street had been used as an exchange, where merchants met to transact business, until 1794 when a new building was constructed in Exchange Alley, off Lowgate; this building was replaced by the late 19th century Exchange. The Bowlalley Lane building was described as "... one of the chief ornaments of the town ..." and housed, as well as the Exchange, the Hull Chamber of Commerce and Shipping and the offices of the Midland Railway Company.[11]

The branch office of the *Leeds Mercury* was situated at No. 48 Lowgate. Hull's earliest newspaper was probably the *Hull Courant* which existed by 1746. By the end of the 19th century there were ten newspapers published in the town, including the *Daily Mail*, founded in 1885.

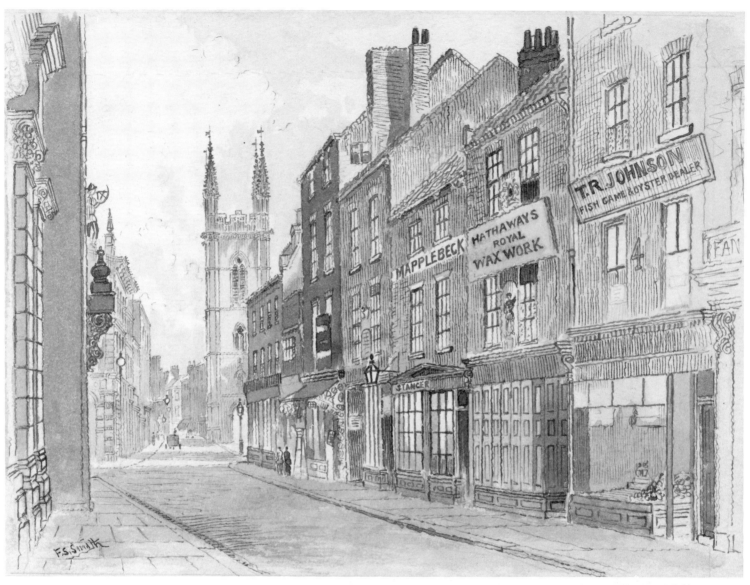

72. Lowgate looking north, c.1883
(Acc. No. 58.1929)

The drawing depicts Lowgate between Bishop Lane and Scale Lane around 1880. Various shops were situated in this area; the premises illustrated include those of George Stancer, a tobacconist, Thomas Mapplebeck, an umbrella maker, and Thomas Johnson, a fish merchant.

The figure holding the sextant on the left hand side of the drawing was probably the shop-sign of Henry Ramsay, chronometer maker, optician, watch and clock maker and jeweller. Spectacles were originally made by jewellers and watchmakers as they possessed the technical skills to make the frames and the lenses. The Worshipful Company of Spectacle Makers, a London Livery company, had been founded in 1629 but it was not until the end of the 19th century that the British Optical Association began to examine and qualify opticians, and government registration of opticians only began in 1958.

Hathaways' Royal Waxwork stood opposite Ramsay's premises. Waxworks were popular in the 19th century; Springthorpe's Popular Waxworks exhibited in Hull and Madame Tussaud's figures were displayed at the Minor Theatre in Humber Street in 1826.

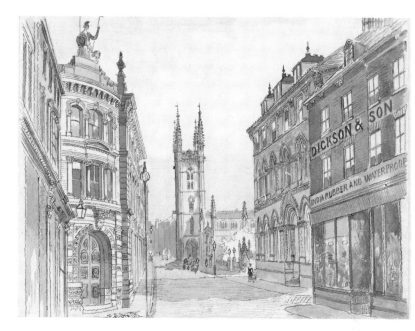

73. The Lowgate looking north from Bowlalley Lane, c.1883
(Acc. No. 60.1929)
This view of Lowgate shows the Exchange on Bowlalley Lane and the Yorkshire Buildings by Bishop Lane. The 19th century 'Gothic' building, built in 1874, was used partly as offices.

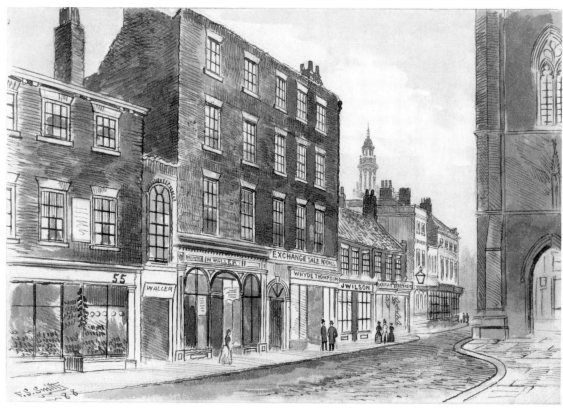

74. Lowgate from St. Mary's Church, 1888
(Acc. No. 66.1929)
The entrance to Manor Alley can be seen, in this view of Lowgate looking north, between the premises of Henry Bennett, a butcher, and the *Guildhall Vaults*. The surname of the landlord, John Dobson, is written on the building.

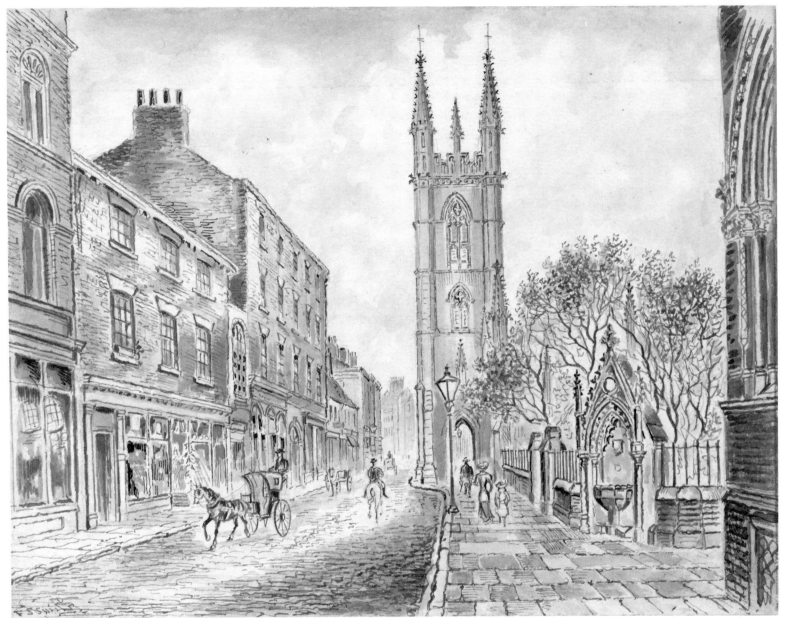

75. St. Mary's Church, Lowgate
(Acc. No. 415.1981.111)
Sponsored by Burstalls – Solicitors and Commissioners for Oaths

St. Mary's Church was originally built as a chapel of ease for the parish of North Ferriby. The earliest known reference to the chapel dates from 1327; in 1333 the chapel became a parish church in practically everything but name. St. Mary's was not styled as a vicarage until 1868. The chapel was referred to as being newly built in 1333 but rebuilding probably took place in the 15th and early 16th centuries. Although traditionally the tower is said to have been pulled down by Henry VIII in 1541, so that the materials could be used in the construction of the fortifications on the east bank of the River Hull, it is more probable that the tower collapsed in 1518. It was rebuilt in 1697 and in 1861, during major restoration work, it was embellished, heightened and pierced with an archway for the footpath to help relieve congestion in Lowgate. The 1861 restoration work was carried out by Sir Gilbert Scott, a cousin of the vicar and a leading 'Gothic Revival' architect.
A hansom cab, a public hire vehicle, is depicted in the centre of the drawing.

76. The Old Town Hall, Lowgate, 1913
(Acc. No. 415.1981.18)
The Guildhall stood originally at the south end of Market Place but by 1805 it had fallen into disrepair and it was ordered to be pulled down. Following the demolition of the Guildhall, the Corporation met in a house on Lowgate which was rented from the Mayor, William Jarratt, and then bought. In 1862 the foundation stone of a new Guildhall was laid and by 1866 the building was completed. It stood on Lowgate, between Leadenhall Square and Hanover Square, partially occupying the site of Jarratt's former house. It was designed by Cuthbert Brodrick, in "... the Italian, or classical" style and was richly decorated, both externally and internally, in a "... chaste and appropriate" manner.[12] The Guildhall was then rebuilt in stages between 1903-16 on the same site, the building depicted by Smith being demolished in 1912. Part of its tower, the Cupola, survives in Pearson Park. Other parts of the Town Hall survive at Brantingham.

This drawing was made by Smith in 1913, the year after the building was destroyed. The artist was probably working from an earlier sketch made on the site.

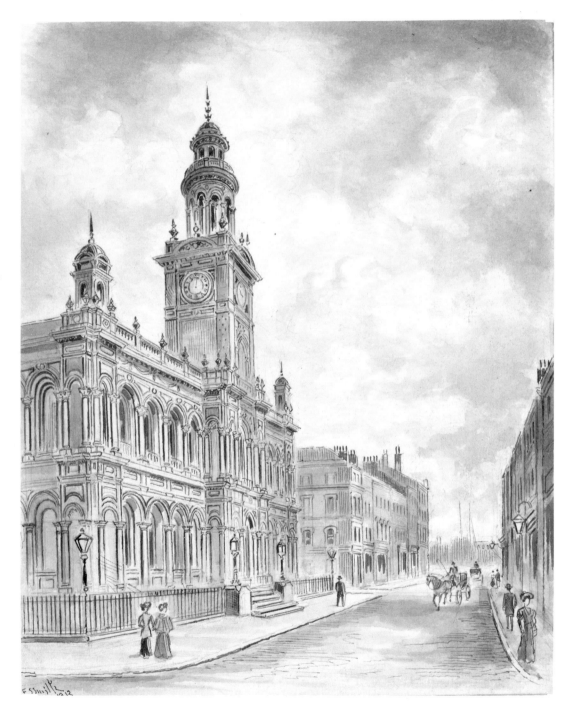

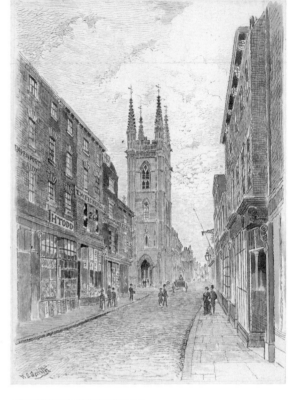

77. Lowgate looking south, c.1883
(Acc. No. 61.1929)
This drawing was made from a point on Lowgate south of the Guildhall, looking south to St. Mary's Church. No. 27 Lowgate was Mrs. Betsey Harrison's hosiery shop; she also had a shop on North Walls, illustrated in Drawing 1.

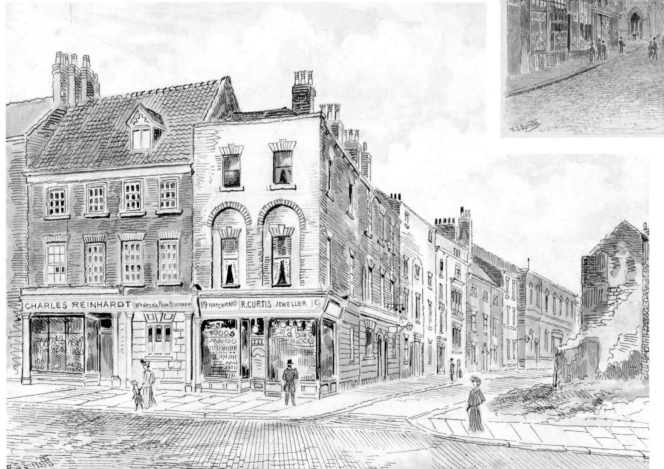

78. George Yard from Lowgate, c.1899
(Acc. No. 415.1981.19)
Smith's sketch depicts Lowgate and George Yard shortly before the construction of Alfred Gelder Street, which resulted in the demolition of part of George Yard and the destruction of the two shops illustrated.

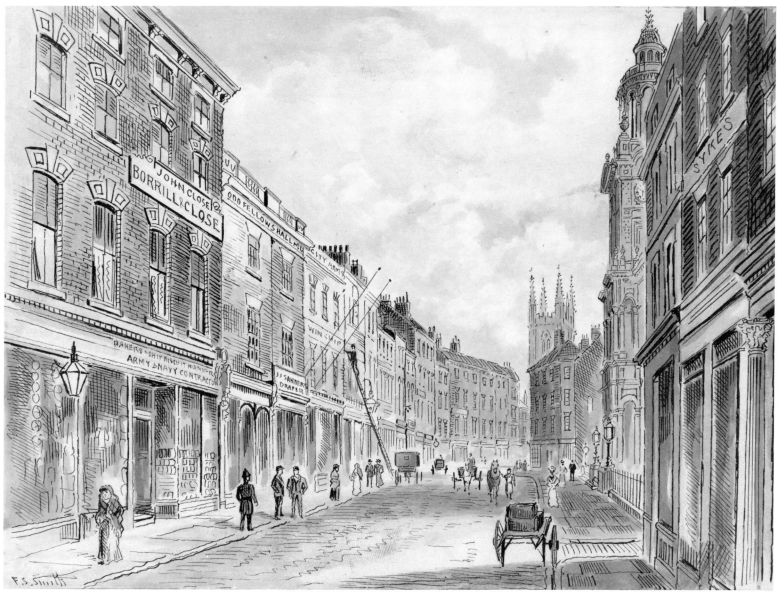

79. Lowgate looking south from Hanover Square corner, c.1895
(Acc. No. 404.1929)

This view of Lowgate was made from a point just north of Hanover Square. The entrance to Hanover Square can be seen on the right hand side of the drawing, by the side of the Guildhall; on the opposite side of Lowgate is the entrance to the Odd Fellows Hall. By the early 19th century there were various Friendly Societies in Hull. These were clubs whose members paid a regular amount into a fund in return for financial support in case of sickness and death. National affiliated 'orders' also developed, which combined the roles of the Friendly Societies with the secrecy and rituals of the Freemasons. The Odd Fellows order was first recorded in Hull in 1811; the Manchester Unity of Odd Fellows purchased the meeting hall off Lowgate in 1855. The building, a former meeting house of the Society of Friends, was situated in a courtyard off the street.

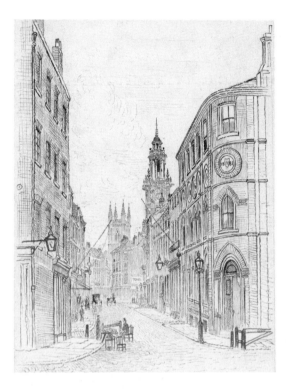

80. Lowgate from Queen's Dock Side, c.1884
(Acc. No. 55.1929)
A view looking south down Lowgate from the south side of Queen's Dock. The building with the date plaque on the right was originally a wine warehouse. It is now the City Record Office.

81. Ellis's Hospital, Long Entry, Salthouse Lane, 1888
(Acc. No. 641.1982.11)
Ellis's Hospital was founded by Joseph Ellis, who died in 1683. A hospital on Salthouse Lane was rebuilt in 1829 and called Ellis's Hospital. The building closed in 1887.

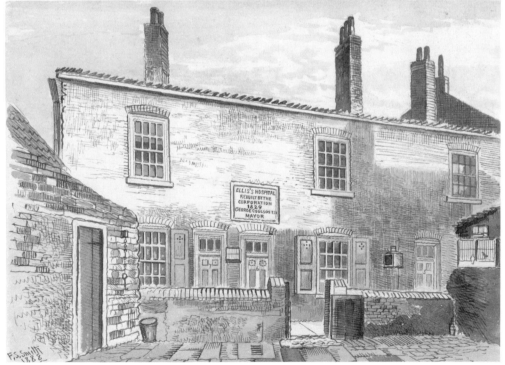

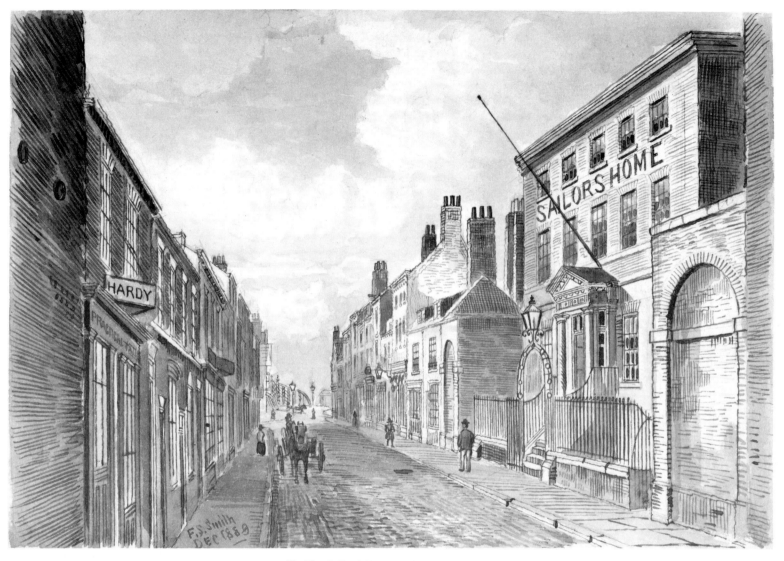

82. The Sailors' Home, Salthouse Lane, 1889
(Acc. No. 330.1929)

Salthouse Lane was a main west-east route through the 19th century town, as it connected Lowgate with Drypool Bridge and East Hull. Smith's drawing shows part of the bridge in the distance and the Sailors' Home on the right hand side. The house was built in c.1780 of brick, with blank-arched side pavilions and a porticoed entrance on Salthouse Lane. The main entrance of the building, which has been converted into flats, is now on Alfred Gelder Street. The building was used as a branch of the Bank of England until the mid 19th century; in May 1860 it opened as the Sailors' Home, providing board, lodgings, recreation facilities and safe deposit provisions for seamen in the port. The Mariners' Church Society ran a mission to the home, distributing religious tracts in different languages every Sunday.

The name Salthouse Lane derives from a salt store or boiling house which stood in the area; Sheahan refers to a former salthouse left to Johanna Putfra in 1337.[13]

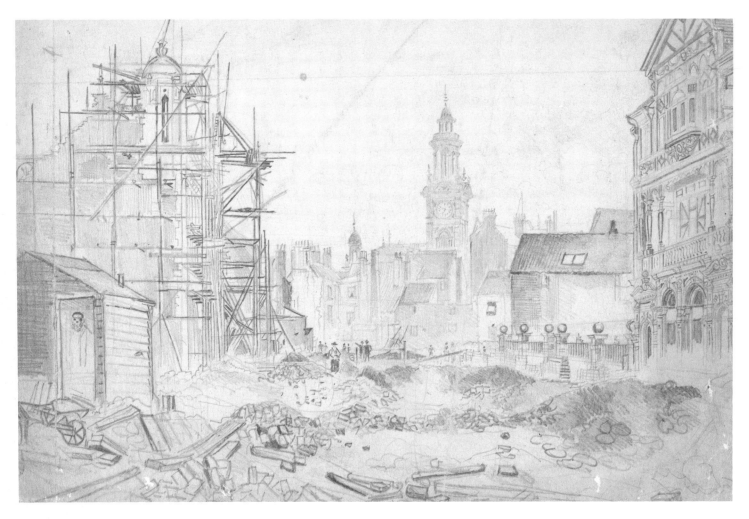

83. The Construction of Queen's Hall, c.1905

(Acc. No. 134.61.8)

Queen's Hall was built by the Wesleyan Methodists in 1905. It stood on the newly laid out Alfred Gelder Street, near the site of the former George Yard Chapel, and was designed, in a 'Gothic' style, by Sir Alfred Gelder. The hall was stone built, at the cost of £20,000; it was replaced by a hall in King Edward Street in 1960 and demolished in 1965. Smith's drawing shows the hall in the course of construction with the White Hart Hotel on the right of the picture and the old Guildhall tower in the distance.

The first Methodists in Hull were converted by Elizabeth Blow of Grimsby in 1746. John Wesley visited the town several times and by the end of the 18th century Methodism was established in Hull. During the second half of the 19th century the number of chapels and meeting halls expanded greatly, particularly in the suburbs, but the inner areas of the city were also served by meeting halls such as Queen's Hall, built during the early 20th century.

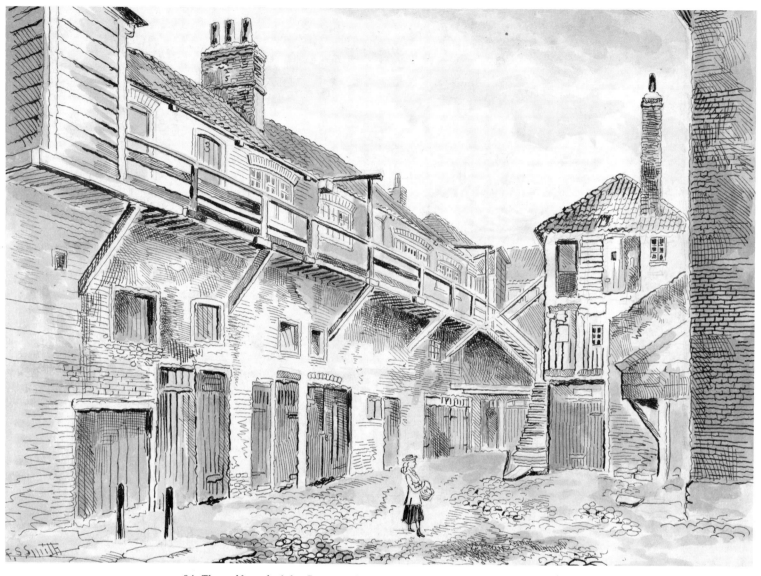

84. The stableyard of the George and Dragon and Meggitt's Buildings, George Yard
(Acc. No. 415.1981.9)

The *George and Dragon* or the *George Inn* stood in George Yard, an alley which ran between Lowgate and High Street. The building was probably constructed in the 15th century and attached to one of the walls was a carved and gilded depiction of St. George and the dragon. Before the Reformation pilgrims to the shrine of St. John of Beverley were traditionally supposed to have stayed at the *George*.

In the 19th century the area between Lowgate and High Street was a maze of courts and alleys, filled with housing. Smith's drawing of the stableyard of the inn looking east shows Meggitt's Buildings on the left hand side. The buildings appear to have consisted of stabling or storage below and dwellings above, reached via stairs and a gallery. The buildings were served by a water tap in the courtyard. George Yard has been demolished and new developments are now taking place on the site.

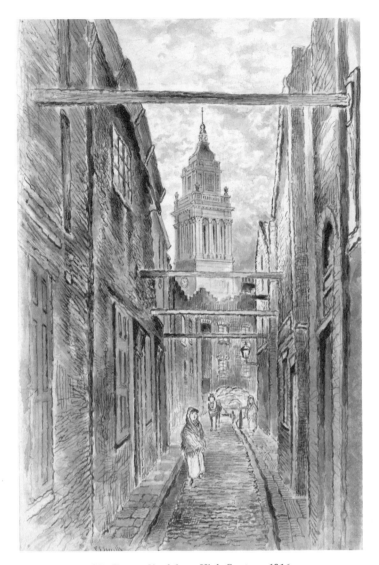

85. George Yard from High Street, c.1916
(Acc. No. 65.62.2)
A view of George Yard looking west to Lowgate. The tower of
the Guildhall, constructed on the site of the building
demolished in 1912, may be seen in the distance.

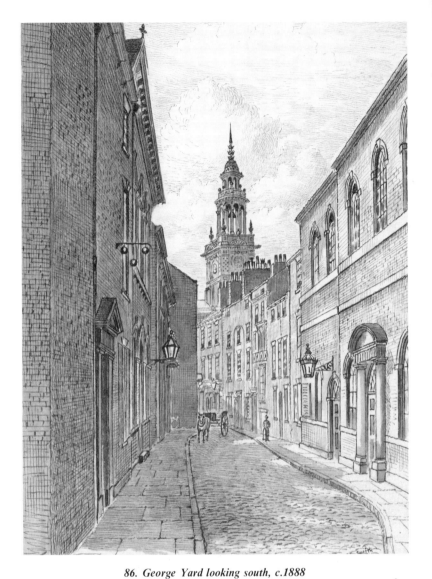

86. George Yard looking south, c.1888
(Acc. No. 18.1929)
George Yard Chapel, which is depicted on the right of Smith's
sketch, was built in c.1786 by the Wesleyan Methodists. A
pawn-broker's sign hangs on the building opposite and the
tower of the old Guildhall is visible beyond the houses.

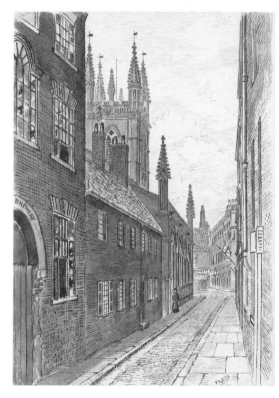

87. Chapel Lane looking west, c.1883
(Acc. No. 63.1929)
Harrison's and Fox's Hospital, the building depicted between St. Mary's Church and the Dossor Brewery in Smith's drawing, was an almshouse founded in the 16th century and enlarged after 1795. The building, which was sold in 1898, has been demolished.

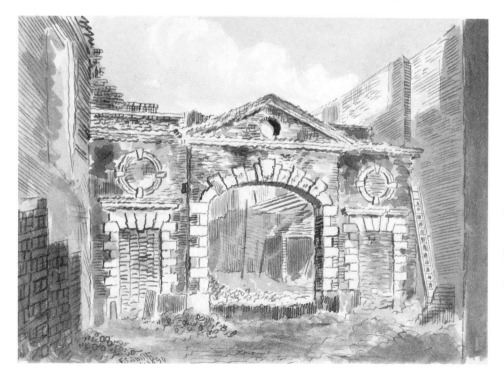

88. Bishop's Palace (?), Bishop Lane
(Acc. No. 415.1981.5)
"It is said that in former times the Suffragen Bishop of Hull had a stately palace — with lofty gates and towers — in [Bishop] Lane ..."[14] The gateway drawn by Smith may have been part of the former palace.

81

89. Bishop Lane looking west, c.1883
(Acc. No. 82.1929)
Smith's sketch shows Bishop Lane looking west to Lowgate. The figure of Britannia on the Exchange at the corner of Bowlalley Lane can be seen in the distance. Bishop Lane and Bowlalley Lane originally formed one street known as Bishopgate.

90. Stewart's Yard, High Street, 1889
(Acc. No. 21.1929)
This drawing illustrates the court housing which existed in the Old Town in the 19th and early 20th centuries. The appalling conditions in which many people lived caused ill-health and social problems.

82

91. Scale Lane looking west, 1883
(Acc. No. 83.1929)
A view of Scale Lane from the High Street end of the road. The *Manchester Arms* is shown on the left; the name of the landlady, Mrs. Ellen Bothwick, can be seen on the façade.

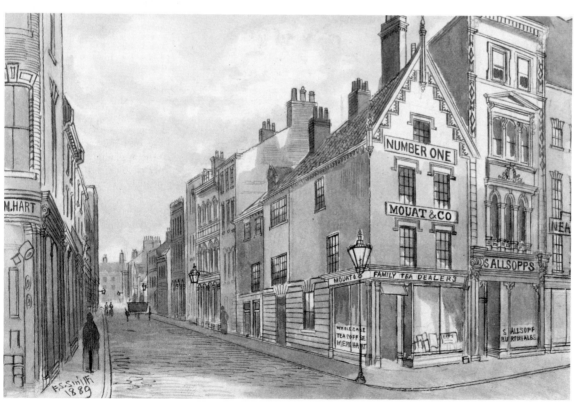

92. Scale Lane from Silver Street, 1889
(Acc. No. 64.1929)
This sketch illustrates the west end of Scale Lane and the northern end of Market Place. Scale Lane divides Lowgate and Market Place; the address of G.M. Hart, hatter and hosier, was 43 Lowgate, that of Mouat & Co. was 1 Market Place.

93. *Scale Lane looking towards High Street*
(Acc. No. 413.1929)

The buildings depicted in this drawing of the eastern end of Scale Lane have changed very little since Smith drew them about 100 years ago. The *Manchester Arms* and the next door building still stand as do the buildings on the left of the sketch. The *Manchester Arms* was rebuilt in c.1896, on the site of the earlier public house. The 'jettied' building next to it is possibly the earliest surviving timber framed building in Hull, although it has been extensively encased. It is now used as business premises.

Scale Lane was named after the Skayll or Scale family who owned property in this area of the town. Along with Whitefriargate (and Silver Street) Scale Lane originally formed part of a road called Aldgate, but the name changed between 1350 and 1500. The *Hull Packet and Humber Gazette*, a newspaper which first appeared in 1787, was published in Scale Lane and the artist William Etty, (1787-1849), served as an apprentice in the newspaper's printing office.

94. Grimsby Lane (?), 1889
(Acc. No. 9.1929)
This drawing probably depicts Grimsby Lane, a street which
lay south of Church Lane and which ran between Market Place
and High Street.

95. Church Lane, c.1899
(Acc. No. 437.1929)
No.12 Church Lane was occupied around the turn of the
century by Joseph Rudkin, a chimney sweeper. A sweep's
brush is suspended on the front of the building below the
house number.

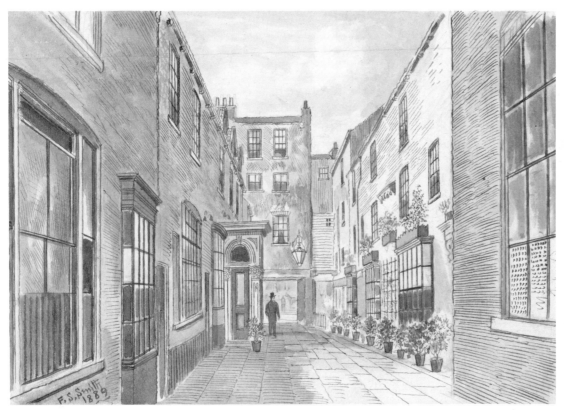

96. The yard of the Cross Keys, 1889
(Acc. No. 334.1929)
Hull's first railway opened in 1840 and during the second half of the century trains took the place of long distance coaches. By 1889 the *Cross Keys*, formerly a coaching inn, was advertised as a commercial and family hotel.

97. De la Pole House, High Street
(Acc. No. 76/48)
De la Pole House was "... once the residence of the noble family of that name ... The house is first mentioned as the residence of John Rotenherying ... whose memory is preserved by Rotenherying Staith, which adjoins this house".[15]

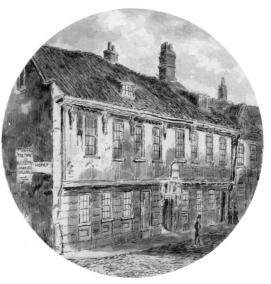

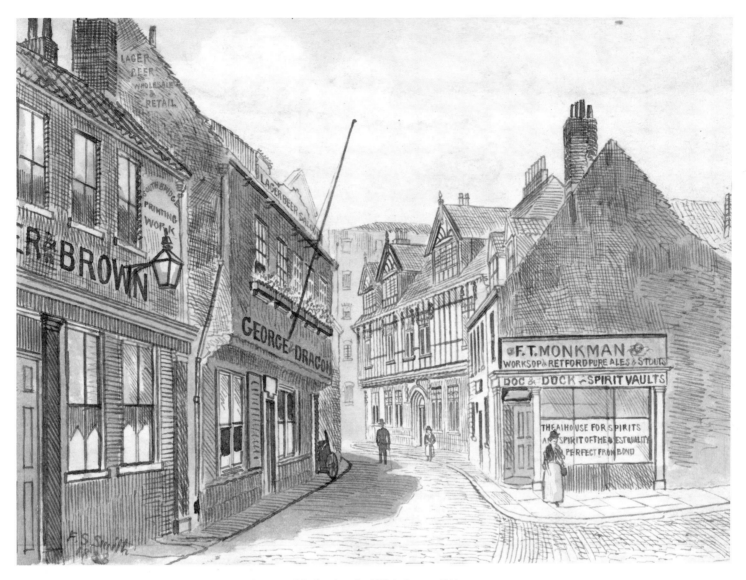

98. South end of High Street, 1888
(Acc. No. 8.1929)
Sponsored by Gordon Scott & Sons (Newland) Ltd

De la Pole House, "... a long, two-storeyed, quaint old building, the upper storey overhanging, and ornamented on the front with curious old carved wooden figures [was] ... taken down in 1882, and re-built in the spirit of its old style, but much elaborated. The old eaves and cornices, with their curiously-carved figures, were preserved, and placed in the new building in their original positions."[16] The rebuilt de la Pole House can be seen in Smith's drawing of the south end of High Street, beyond the *Dog and Duck* public house.

The road by the side of the *Dog and Duck* led to South Bridge, which was opened in 1865. A small toll was charged for crossing the bridge, which spanned the River Hull, from the corner of High Street and Humber Street to Garrison Side. A ferry across the river operated in the area in the first half of the century. The bridge was taken down in 1934.

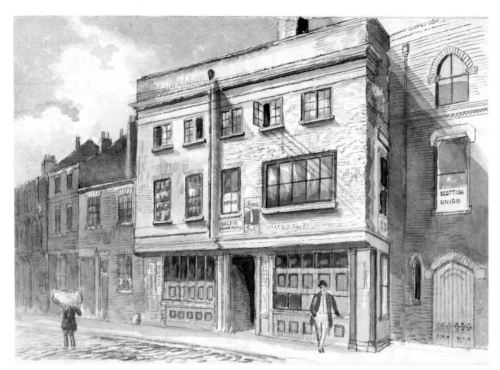

99. Baltic Chambers, High Street
(Acc. No. 22.1929)
This building stood on the west side
of High Street, south of Scale Lane.
Baltic Buildings are marked in the
area on the 1:500 Ordnance Survey
map of c.1888-1892.

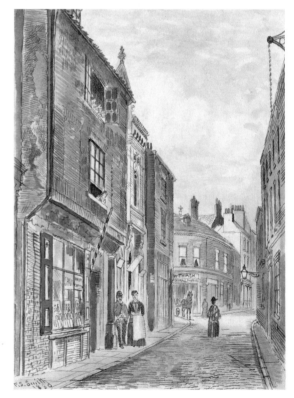

**100. High Street near Church Lane,
1889**
(Acc. No. 6.1929)
This view of High Street looking
north shows the corner of Church
Lane on the left, with the entry to
Church Lane Staithe opposite. The
striped pole marks the shop of
William Sandyfirth Grayson, a
hairdresser.

101. Crowle House, High Street, 1889
(Acc. No. 326.1929)

Sponsored by Thos. E. Kettlewell & Son Ltd –
The Shipbrokers

The 17th century façade of Crowle House is the surviving fragment of an earlier property which was taken down and rebuilt by Christopher Ringrose in 1849. The original building on the site was called Leyons or Lion House. The name derived from the carved panels beneath the windows and from a Latin inscription, which translated read, "These lions which thou seest engraven on the front, refer thee to what was my ancient name".[17] In the 14th century the house belonged to John Tutbury, a merchant and mayor of Hull. A later mayor, George Crowle, who founded Crowle's Hospital (Drawing 41), rebuilt or added another entrance to the house in 1664. The date and the initials of Crowle and his wife, Eleanor, were incorporated into the decoration of the building; they may be seen in Smith's drawing on either side of the 'jewelled' pilasters adorning the central section. The building, which may have been used as a coffee house in the late 18th or early 19th centuries, is now used as offices.

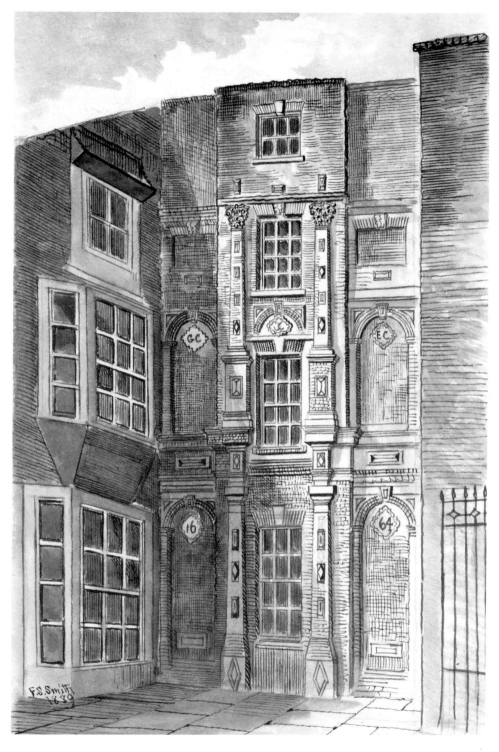

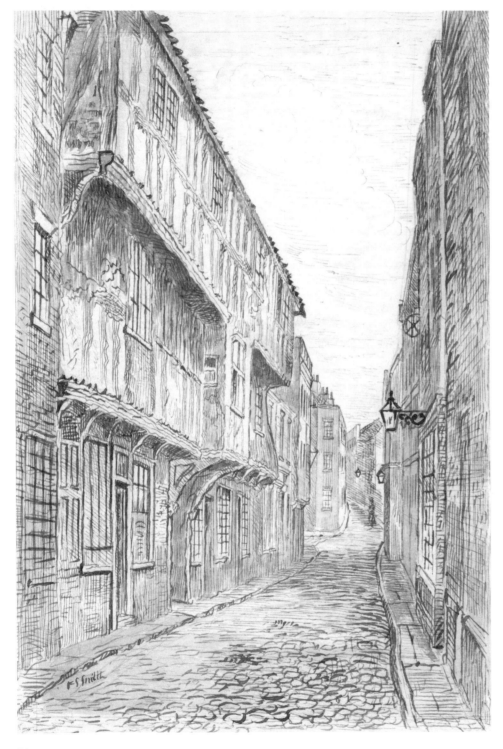

102. King's Head Inn, High Street
(Acc. No. 14.1929)

The *King's Head Inn* was one of the oldest buildings in Hull until its destruction this century. The brick and timber construction may have dated from the late 14th century; traditionally it was the place where John Taylor, the 'Water Poet', stayed in 1622 —

> 'Thanks to my louing host and hostesse *Pease*,
> There at mine inne, each night I tooke mine ease:
> And there I got a cantle of *Hull* cheese One euening late ...'[18]

'Hull cheese' was a strong ale; to have eaten Hull cheese was to be drunk. The town's strong ale was often commented on by visitors to Hull and in the 16th century the Corporation and clergy condemned the "... drunkenness, disorder, and infinite abominable and detestable sins which do abound by reason of the ... unreasonable and excessive strong ale ..." brewed and drunk in the town.[19] The *King's Head* was demolished in 1905.

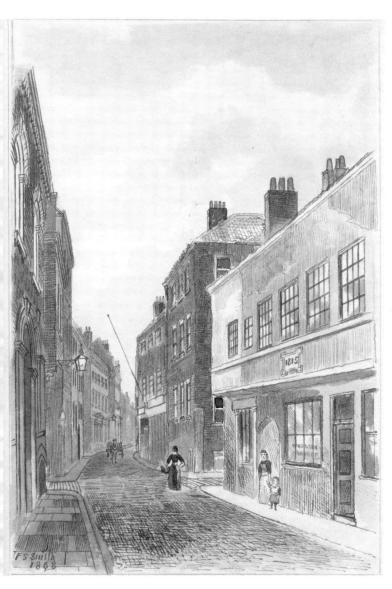

103. High Street looking south near Bishop Lane, 1888
(Acc. No. 12.1929)
The entry to Bishop Lane may be seen on the right and on the
left is the corner of Bishop Lane Staithe. The premises used by
William Hudson, shipbroker, have been demolished and the
site has been redeveloped.

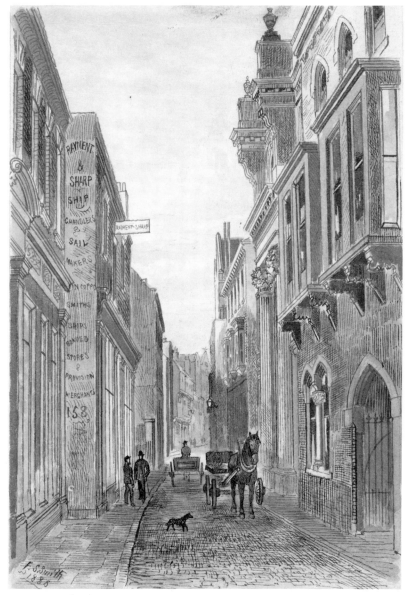

104. High Street and the Corn Exchange
(Acc. No. 641.1982.7)
The building on the right, which is now the Hull and East
Riding Museum, was formerly the Corn Exchange. The design
of the frontage was inspired by a Roman triumphal arch;
fittingly, the building now contains the city's archaeological
collections.

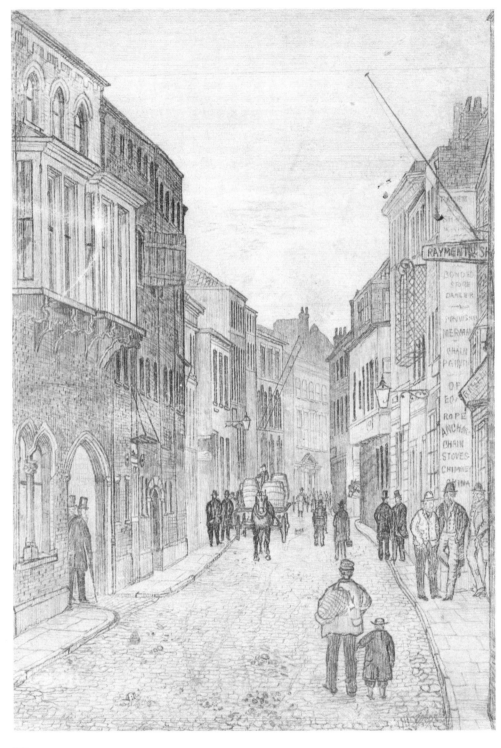

105. High Street looking south near the Corn Exchange, c.1880
(Acc. No. 415.1981.14)
The Old Harbour was the only anchorage for ships in Hull until the construction of the town docks in the late 18th and early 19th centuries, and many of the town's merchants lived in High Street, the road running along the bank of the Haven, until the opening of the new docks led to foreign-going vessels largely abandoning the River Hull.

Smith's drawing shows the street after it had changed into a warehousing and business area (although many working people continued to live in the court-housing off the street). The building on the left was used as offices by, among others, a firm of corn merchants, and men in formal office dress and top hats may be seen at the entrance. Next door to the building is a warehouse, built in 1829 for William Walker, a warehouse keeper and iron merchant. A ladened rully is depicted in the centre of the sketch and on the right the premises of the ship chandlers, Rayment and Sharp, may be seen.

106. Maister House, High Street, 1889
(Acc. No. 327.1929)
*Sponsored by Gelder and Kitchen –
Chartered Architects and Surveyors*
No.160 High Street was the home-
cum-office of the Maisters. The family
settled in Hull in the 16th century; by
the 18th century they were one of the
town's leading merchant families. The
original house on the site was severely
damaged in a fire in 1743, in which
Mary Maister, her baby son,
Nathaniel, and two maids died.
Henry Maister had begun to rebuild
the house to designs by Joseph Page,
before his death the following year.
Joseph Page was trained as a
bricklayer-plasterer. Many such
craftsmen referred to themselves as
'architects' although they relied on
architectural pattern books for their
designs; Page also used pattern books
but he was perhaps the first
recognisable architect as such to work
in Hull. The house has a fairly plain
exterior; the interior is dominated by
a magnificent stone staircase, said to
have been built to reduce the fire-risk
but probably constructed to impress
rather than protect. The house is now
owned by the National Trust and is
used as offices by a firm of architects.

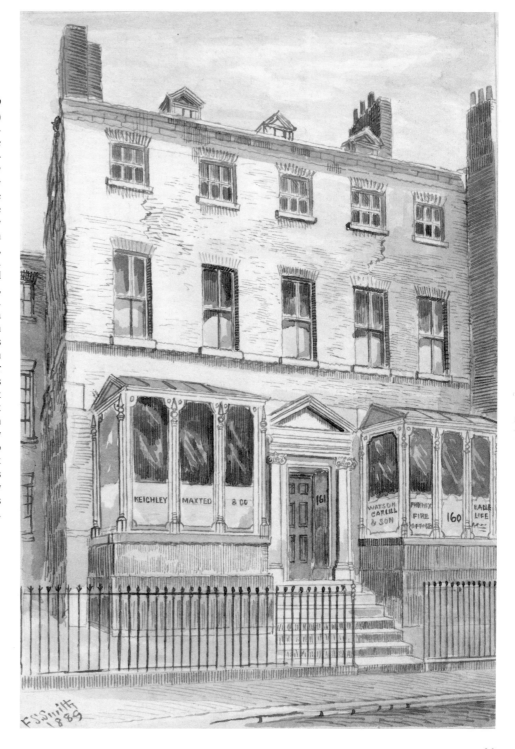

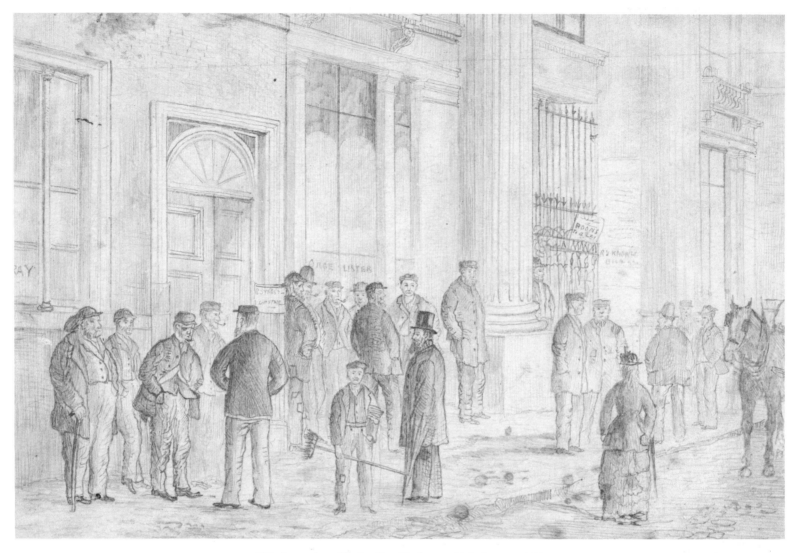

107. A crowd outside the Corn Exchange, High Street, c.1882
(Acc. No. 459.1929)

This is an unusual drawing by Smith as he has taken a group of people as his subject rather than a building or a group of buildings. The sketch illustrates part of No.35 High Street; premises used by William Gray, a seed-crusher, and George Sykes and Sons, merchants; and the entrance to the old Corn Exchange, which was occupied by Richard Knowles, a produce importer, among others.

The group includes people from a variety of trades and professions. The man in the centre of the drawing is wearing a frock coat and top hat, the formal office dress of the period. Next to him is a young boy holding a broom, who was possibly a street sweeper. The man on the far left of the sketch appears to be wearing a porter's hat. This was a hat with a padded flap at the back which protected the neck and supported heavy loads. The other men in the picture seem to be wearing the working clothes of the time.

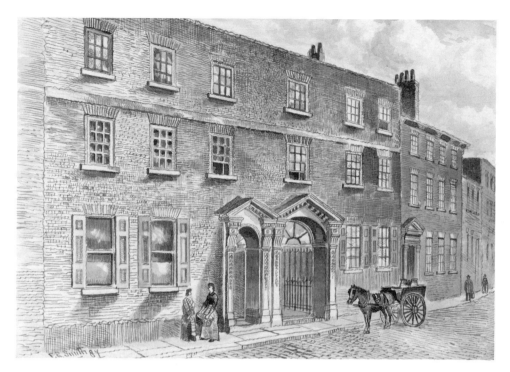

108. Georgian property in High Street, 1887
(Acc. No. 3.1929)
The horse-drawn cart on the right appears to contain two milk churns. Because of the difficulties in transporting fresh milk from the country, cows were kept in the town into the 1970s.

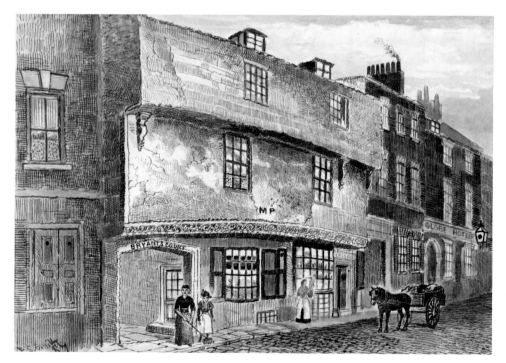

109. No.179 High Street, 1887
(Acc. No. 19.1929)
Sponsored by Kingston Communications (Hull) plc
No. 179 High Street, at the entrance to Bryant's Court, was formerly occupied by Richard and Isabel Sissons, who "... were amongst the earliest converts to Quakerism" in the town.[20]

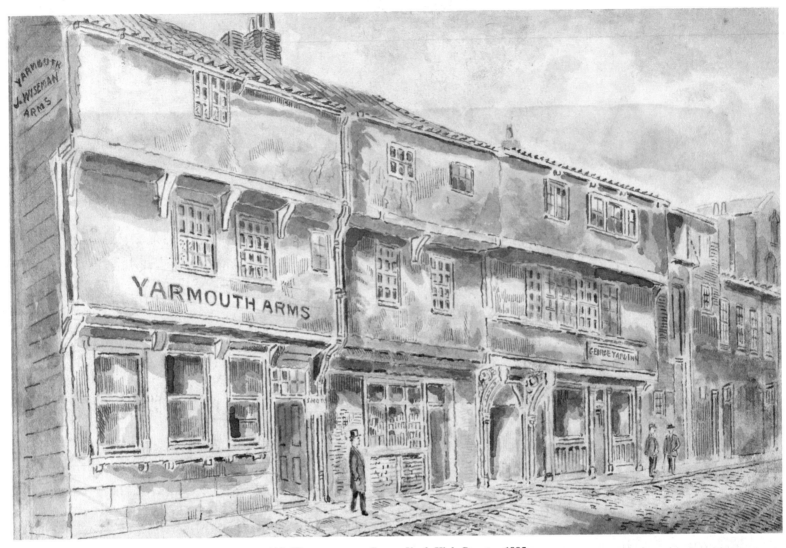

110. The entrance to George Yard, High Street, c.1885
(Acc. No. 641.1982.9)

The timber-framed building, which stood at the entrance to George Yard, probably dated from the 15th century. The entrance to the alley lay through the doorway, decorated with carved brackets, depicted in the centre of Smith's drawing; the *George Yard Inn* stood on the north of the entry and to the south was No.169 High Street and the *Yarmouth Arms*, whose landlord in 1885 was John Wiseman. According to Hadley, the 18th century Hull historian, the building had been given to the Corporation by the Scale family in 1556 and the upper floor above the entrance had been used as a Cloth Hall, where cloth was examined before sale. The Society of Merchants, founded in 1567, met for a time in the old Cloth Hall; by 1598 most of the building had probably been converted into an inn. The building was demolished in 1943.

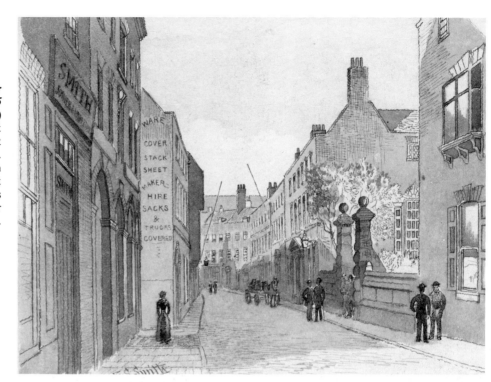

111. High Street near Wilberforce House, c.1885
(Acc. No. 13.1929)
This view shows High Street looking north from a point south of Wilberforce House. The gateway to the house can be seen on the right; on the left are the premises of Charles Ware, a waterproof oil cover maker.

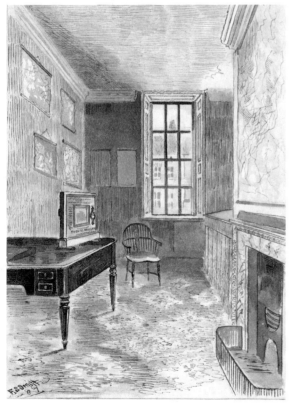

112. The Birth Room, Wilberforce House, 1887
(Acc. No. 331.1929)
This room is traditionally said to be where William Wilberforce was born. In 1887 the house was being used as offices by several businesses, including seed-crushers and corn merchants.

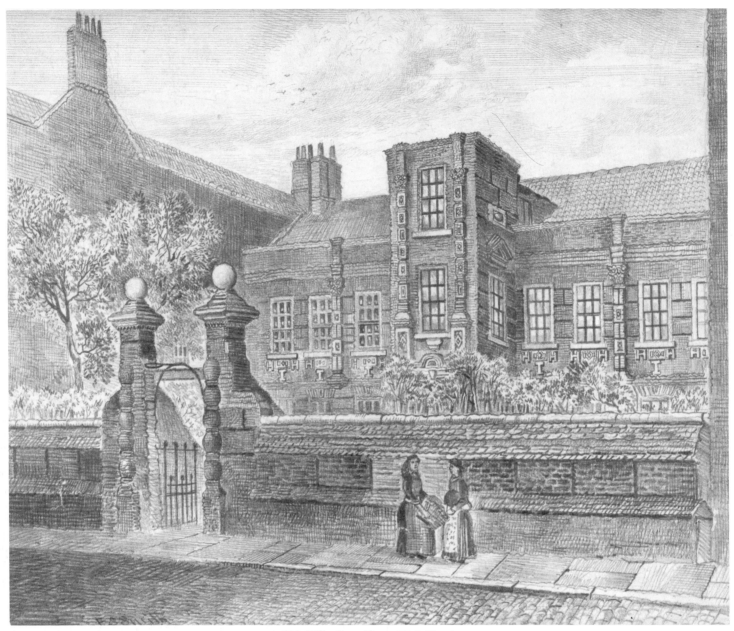

113. Wilberforce House, High Street
(Acc. No. 641.1982.4)

Wilberforce House is one of the few surviving merchants' houses on High Street. In the 17th century a house on the site was owned by the Listers, one of the leading families in Hull at the time. Sir John Lister was a successful merchant, an alderman and one of the town's MPs; when Charles I visited Hull in 1639 Lister entertained the King at his house in High Street. The house was either rebuilt or extensively remodelled in the late 17th century and was altered again in the mid-18th century when it was owned by the Wilberforce family. The Wilberforces were also merchants; rooms on the ground floor of the house would probably have been used as offices whilst the family would have occupied the rest of the building. William Wilberforce, who devoted much of his life to the fight against slavery, was born in the house on 24 August 1759. In 1906 the building was opened as a museum and it now contains displays about Wilberforce and the abolition of slavery, as well as collections of costume, silver, dolls and furniture.

114. Prince's Chambers, High Street, 1888
(Acc. No. 2.1929)
"... three very old dilapidated tenements ... were pulled down in 1863, and a handsome building, called "Prince's Chambers", erected in their stead".[21] The entry to Salthouse Lane Staithe may be seen on the right; Salthouse Lane corner is hidden by the rully.

115. High Street near Salthouse Lane, c.1883
(Acc. No. 84.1929)
Smith's drawing depicts High Street looking south from a point south of Salthouse Lane. The buildings beyond the archway on the left are Georgian Houses, built in c.1756, and now occupied by the city's Museums Service.

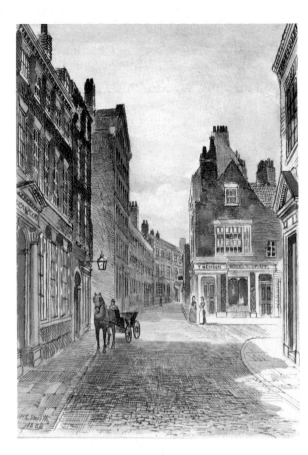

116. High Street looking south across Salthouse Lane, 1888
(Acc. No. 10.1929)
A view of High Street with the corner of Salthouse Lane on the right. The entry to Salthouse Lane Staithe is hidden by the carriage, which may be a victoria.

117. No.11 High Street, 1886
(Acc. No. 641.1982.2)
In 1888, this Georgian property was being used as offices by businesses such as the engineering firm, Alfred Simpson & Co.. Salthouse Lane Staithe, entered via an archway, is visible on the extreme right.

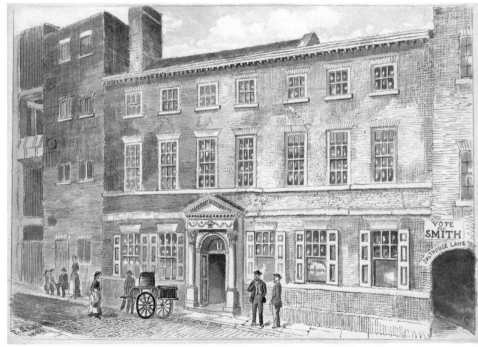

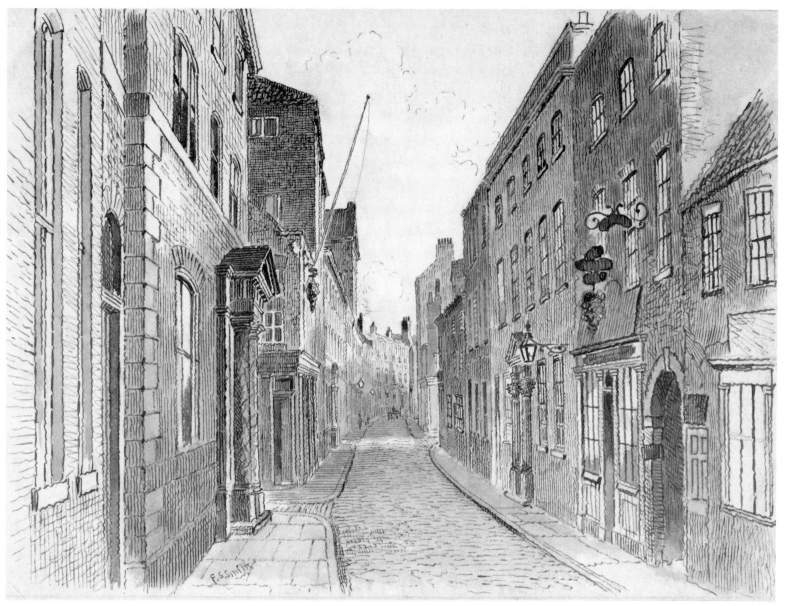

118. High Street near Blaide's Staithe, looking south
(Acc. No. 15.1929)
Sponsored by Blackmore Son and Co. – Chartered Architects

This drawing was made from a viewpoint on the east side of High Street, north of Blaide's Staithe, the entry to which is depicted on the left. The public house on the south side of the Staithe was the *Tigress*; on the opposite side of the street was the *Fleece Inn*. Both public houses were marked by carved bunches of grapes.

The building to the north of Blaide's Staithe was Blaydes House, "... the residence of Benjamin Blaydes, Esq., who three times served the office of Mayor of Hull. Alderman Blaydes was head of the firm of Blaydes, Loft, Gee and Co., shipowners and general merchants, and the first to commence the Hull and Hamburg trade ..."[22] Blaydes House was built c.1760, conceivably to designs by Joseph Page. In the mid-19th century it was bought by Henry Lodge, a seed-crusher, who owned the Phoenix and the Alexandria seed-crushing mills off Blaide's Staithe. The mills were converted into warehouses in about 1910 and have since been demolished. Blaydes House is now used as offices by a firm of architects.

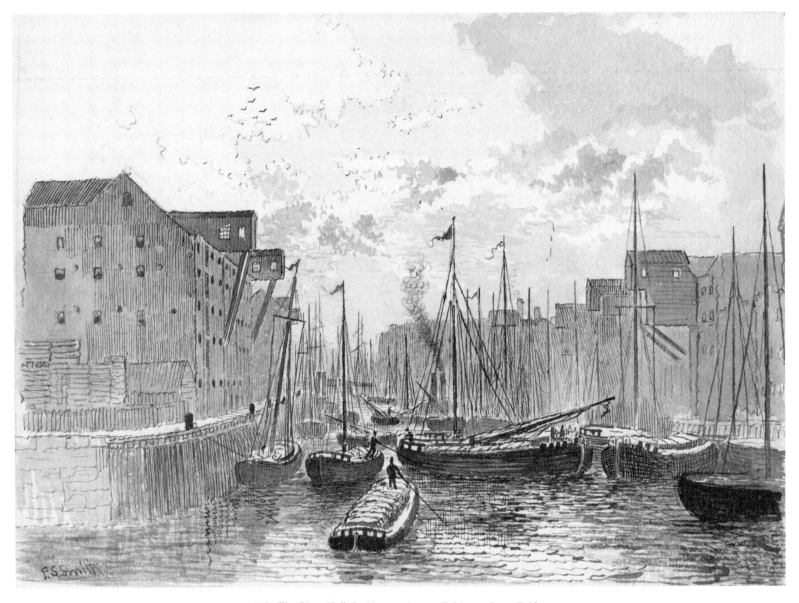

119. The River Hull, looking south near Salthouse Lane Bridge
(Acc. No. 383.1929)

The River Hull between North Bridge and the river mouth was known as the Haven. Until the late 18th century it was the only anchorage for ships in Hull, and as trade boomed and more vessels used the port, the Haven became increasingly congested. The construction of the town docks, and later the docks along the Humber banks, partially relieved the crowding, as large foreign-going ships used these facilities, but smaller vessels continued to use the Haven. Smith's drawing, made from a point on the east bank of the river, shows the anchorage crowded with Humber keels, barges and, in the distance, a small steamer. The entrance to the lockpit of Victoria Dock, opened in 1850, is illustrated on the left; the warehouses which stood along the banks of the Haven are illustrated on both sides of the river. Salthouse Lane (later Drypool) Bridge, which opened in 1889, lay to the north of Smith's viewpoint.

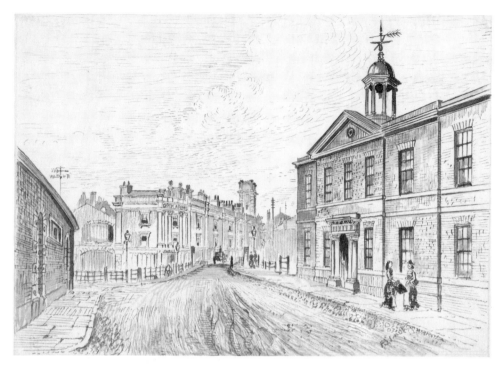

120. The Old Dock Office, High Street, c.1885
(Acc. No. 183.1929)
The old Dock Office was built by the Dock Company in 1820 to replace the smaller offices by the lockpits of Queen's and Humber Docks. The Dock Company moved to larger offices, now Town Docks Museum, in 1871.

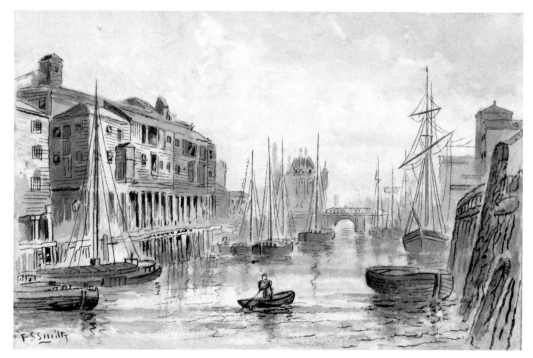

121. The Old Harbour looking north from Drypool Bridge
(Acc. No. 384.1929)
Sponsored by British Cocoa Mills (Hull) Ltd.
The first bridge across the north end of the Old Harbour was built in 1541. The present bridge was built in 1931 on a site to the north of that depicted by Smith. The bridge shown by Smith is the North Bridge of 1870.

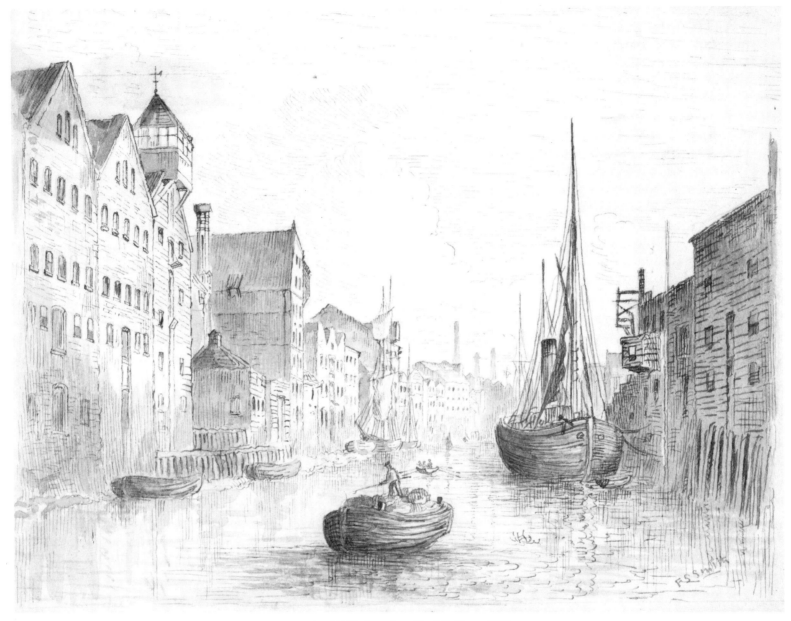

122. The Old Harbour from North Bridge, c.1885
(Acc. No. 393.1929)

Smith's drawing shows the River Hull looking south from North Bridge. A variety of vessels is illustrated in the drawing. The boat on the right may be a 'Billy Boy', a coasting and 'short sea' trading vessel. 'Short sea' traders were built to sail the limited distances to Northern Europe and France. The river banks were lined with warehouses and mills. Some vessels in the late 19th century (and in the 20th century) continued to unload their cargoes directly into the warehouses or the mills, instead of transferring the goods to barges.

Notes

1. Lambert, Revd J.M. *op.cit*, p.5.

2. Wrigglesworth, Edmund *Illustrated Guide to Hull with a Glance at its History*, 1890, A. Brown & Sons, Hull, p.74.

3. *Ibid*, p.104.

4. *Ibid*, p.105.

5. Sheahan, James Joseph *History of the Town and Port of Kingston-upon-Hull*, 1866, John Green, Beverley, p.663.

6. Wrigglesworth, Edmund *op.cit*, p.52.

7. White, William *White's General and Commercial Directory of Hull*, 1882, William White, Sheffield, p.87.

8. Wrigglesworth, Edmund *op.cit*, p.53.

9. *Ibid*, p.64.

10. *Ibid*, p.64.

11. *Ibid*, p.69.

12. *Ibid*, p.75 and pp.77-78.

13. Sheahan, James Joseph *op.cit*, p.407.

14. Wrigglesworth, Edmund *op.cit*, p.88.

15. *Ibid*, p.93.

16. *Ibid*, pp.91 and 93.

17. Sheahan, James Joseph *op.cit*, p.399.

18. *Ibid*, p.100.

19. Gillett, Edward, and MacMahon, Kenneth A. *A History of Hull*, 1980, University of Hull, p.119.

20. Wrigglesworth, Edmund *op.cit*, p.86.

21. Sheahan, James Joseph *op.cit*, p.393.

22. *Ibid*, p.392.

ACKNOWLEDGEMENTS

I should like to thank David Fleming, (formerly) Principal Keeper of Museums, for his help and advice, and Charles Brook, Managing Director of Hutton Press, for his guidance. Elizabeth Frostick, Keeper of Social History, and Penny Wilkinson, Assistant Keeper of Social History, have given advice and support and I am also grateful to Stephen Goodhand, Keeper of Transport, and Arthur Credland, Keeper of Maritime History. Thanks are due also to Anne Lamb, Dorothy Soulsby and Jayne Karlsen for producing the typescript, and being so patient, and to Deborah Dean for her support.

It would have been impossible to write this book without the co-operation of the staff of Hull Central Library. I am especially grateful to the Local Studies Librarians, Jill Crowther, Margaret Burwell, Sara Goodrick, Karen Noble-Burchett, Dawn Stanley, Janet Fash and Lisa Smith. The staff of Hull City Record Office have also assisted me. I should like to thank Wendy Munday for her detailed preparation of the map of F. S. Smith's Old Town. Finally thanks to Robert Barnard, Richard Hayton and Christopher Ketchell of the Local History Unit, Hull College, for corrections to the original captions.

Carolyn Aldridge

FURTHER READING

ed. Allison, K.J
The Victoria History of the Counties of England, A History of the County of York East Riding, 1969, Oxford University Press, Volume 1.

Calvert, Hugh
A History of Hull, 1978, Phillimore & Co. Ltd., London and Chichester.

Foster, Bernard
Living and Dying, A Picture of Hull in the Nineteenth Century, 1984, Hull.

Gillett, Edward, and MacMahon, Kenneth A.
A History of Hull, 1980, Hull University Press.

Sheahan, James Joseph
History of the Town and Port of Kingston-upon-Hull, 1866, John Green, Beverley.

Wrigglesworth, Edmund
Illustrated Guide to Hull with a Glance at its History, 1890, A. Brown & Sons, Hull.